1881:
BOUQUET OF SUNFLOWERS
(CLAUDE MONET)

1882:
A BAR AT THE FOLIES-BERGERE
(EDOUARD MANET)

1883:
THE MANNEPORTE (ETRETAT)
(CLAUDE MONET)

DANCE IN THE COUNTRY/
DANCE IN THE CITY
(AUGUSTE RENOIR)

1884:
BEER GARDEN IN MUNICH
(MAX LIEBERMANN)

A SUNDAY ON LA GRANDE JATTE
(GEORGES SEURAT)

1885:
THE GULF OF MARSEILLES
(PAUL CEZANNE)

1886:
BRETON PEASANT WOMEN
(PAUL GAUGUIN)

1888:
TERRACE OF A CAFE AT NIGHT
(VINCENT VAN GOGH)

HORTENSE FIQUET IN THE RED DRESS
(PAUL CEZANNE)

1889:
CYPRESSES
(VINCENT VAN GOGH)

A YOUNG GIRL WITH DAISIES
(AUGUSTE RENOIR)

1890:
STILL-LIFE WITH APPLES
AND A POT OF PRIMROSES
(PAUL CEZANNE)

1892:
CATHEDRAL OF ROUEN IN THE EVENING
(CLAUDE MONET)

1994:
THE SOFA
(HENRI DE TOULOUSE-LAUTREC)

1897:
THE BOULEVARD MONTMARTRE
ON A WINTER MORNING
(CAMILLE PISSARRO)

1899:
BRIDGE OVER A POND OF
WATER LILIES (CLAUDE MONET)

1902:
THE PARROT MAN
(MAX LIEBERMANN)

THE CHAMPAGNE SONG
(MAX SLEVOGT)

1903:
THE HOUSES OF
PARLIAMENT
(CLAUDE MONET)

1907:
AFTER THE BATH
(LOVIS CORINTH)

1909:
THE PAPAL PALACE
IN AVIGNON (PAUL SIGNAC)

1880s 1890s 1910s

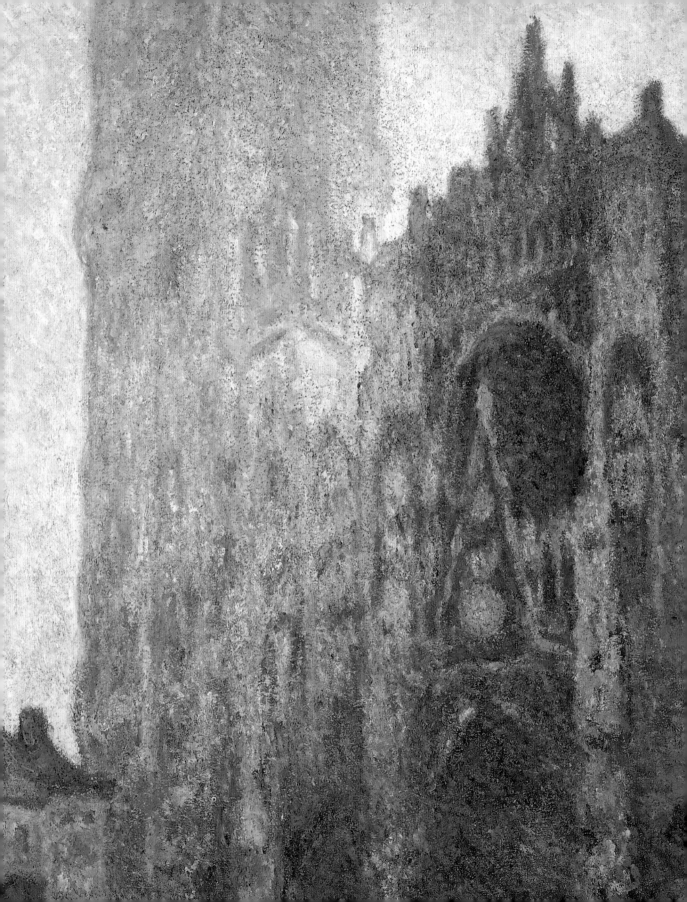

50 IMPRESSIONIST PAINTINGS
YOU SHOULD KNOW

Ines Janet Engelmann

PRESTEL

Munich · London · New York

CONTENTS

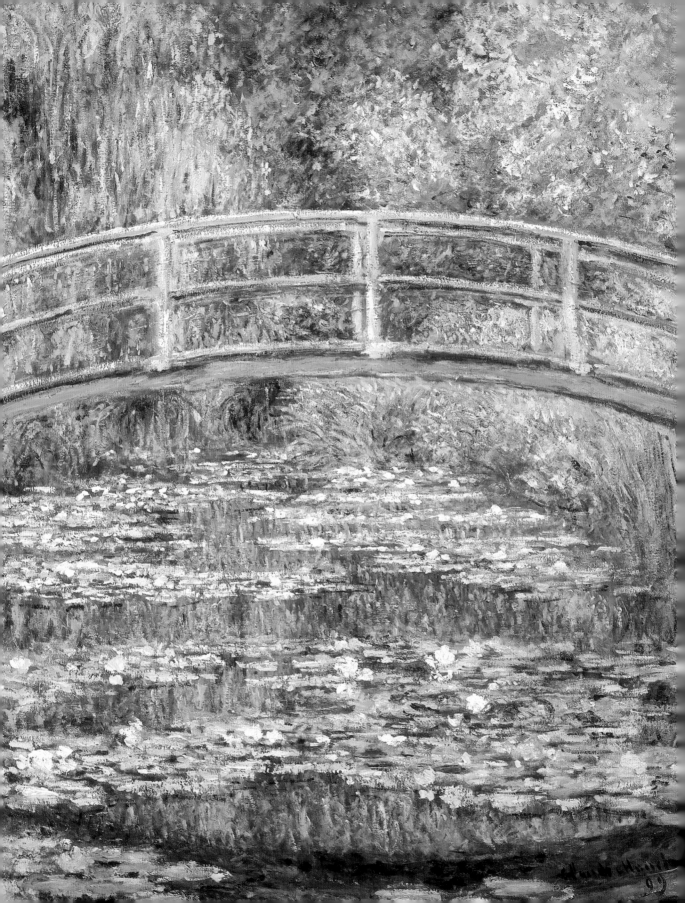

Ines Janet Engelmann

INTRODUCTION

The pictures painted by the Impressionists fulfilled none of the demands required of successful works of the fine arts in the last third of the nineteenth century. It is no wonder that these paintings were regarded at the time as being scandalous or just an amateurish mass of daubs of paint. The painters' working methods and views were new—shockingly so, in the eyes of their contemporaries; they no longer wanted to depict heroic events of times gone by nor to capture biblical or mythological stories, but the modern world they lived in. They wanted to preserve their impressions—their personal feelings, their first concepts—on canvas, many of them preferring to paint in front of the motif, often out of doors, using rapid, light brushstrokes.

To say that the artists who found their way into the history of art as the Impressionists wanted to depict their environment in a novel, subjective manner is a simplified and therefore imprecise description of their intentions, both accurate and false at the same time. Degas depicted contemporary life but never painted in front of the motif, and never out of doors. Based on sketches, the sophisticated composition of his paintings were developed in his atelier. Alfred Sisley set up his easel outdoors and devoted himself exclusively to landscape painting; he had no interest in social portraits. Gustave Caillebotte, Mary Cassatt, Paul Cézanne, Edgar Degas, Edouard Manet, Claude Monet, Berthe Morisot, Camille Pissarro, Auguste Renoir, and Alfred Sisley developed 'a new view of the world in which they lived and a new method for depicting it', influenced by each other but each with his or her individual, unmistakeable style. The painters fervently admired the paintings of Edouard Manet, who became their leader and organised joint exhibitions. Coined by a critic at the time of their first exhibition in 1874, and initially treated with ridicule, the term Impressionists developed into a trademark.

Claude Monet,
Bridge over a Pond of Water Lilies (detail),
1899, oil on canvas, 92.7 × 73.7 cm,
New York, The Metropolitan Museum of Art,
H.O. Havemeyer Collection, bequest
of Mrs. H.O. Havemeyer, 1929

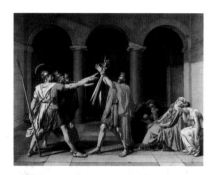

ill. 1
Jacques-Louis David,
The Oath of the Horatii, 1784,
oil on canvas, 330 × 425 cm,
Paris, Musée du Louvre

ill. 2
Jean-Auguste-Dominique Ingres,
The Grand Odalisque, 1814,
oil on canvas, 91 × 162 cm,
Paris, Musée du Louvre

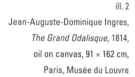

FAVOURITES AND THE REVILED (THE PIONEERS OF IMPRESSIONISM)

'Seat ten moderately gifted people in front of a new, original painting and they will behave like children. Amused, they will turn to each other and make witty statements. . . . They look at a picture in the same way as a child looks at a picture book. People who consider themselves cultured, and have had a conservative art education, are irritated by new types of art which do not conform to their dogmas and viewing habits. None of them makes the effort to look without prejudice. The uneducated person understands nothing and the educated makes too many comparisons. Neither of them is capable of *looking* and, therefore, one is amused and the other enraged Originality is disturbing.'

Emile Zola's observations are pertinent, something the Impressionists could only agree with. To us today, it appears amazing that these airy, cheerful paintings, often flooded with sunlight, could ever have been derided and rejected. However, perhaps it becomes less surprising if one looks at the works which were generally accepted at the time. In the second half of the nineteenth century, Neoclassicism was still popular, the recognised and accepted model.

Its founder Jacques-Louis David (ill. 1) intended 'to lead art back to the principles set down by the Greeks'. He was often inspired by mythology: figures dressed in ancient clothing move solemnly through the classical, stage-like architecture of his paintings. David's compositions are lucid and ordered, his lines, severe and noble, his application of colour so fine that the brushstrokes cannot be discerned. His pupil Jean-Auguste-Dominique Ingres, the most important representative of official nineteenth-century French art and a protégé of Napoleon I, continued painting in the style of his teacher and developed it further. He had no misgivings about deforming bodies in order to sustain the beauty of the line: for example, the back of his famous *Odalisque* (ill. 2) is unnaturally lengthened. Artists who painted like David or Ingres were more or less guaranteed lasting success.

However, gradually resistance to this style developed. Ingres' work is 'the perfect expression of an imperfect intellect', was the polemical way in which Delacroix, the main representative of French Romanticism, talked about the man who was seen as his rival (ill. 3). Delacroix rapidly became the leader of the 'school of ugliness' (ill. 4)—ugly, because his pictures showed passion and movement which had been sacrificed to David's constricting corset of lines, the exact recording of the motif of the picture, anatomical correctness. Delacroix was mainly interested in colour and placed great value on its luminosity, banning dull red, yellow and brown earth tones from his palette and often mixing his colours with white, using tones other than black for the shadows. He applied his paint sometimes thickly, sometimes finely on one and the same picture, abandoning the uniformly worked surface which was regarded as proof of artistic mastery. His contemporaries thought his works chaotic: in their opinion, he was not making any effort but simply exhibiting sketches, a criticism which would later be used against the

Impressionists. In contrast to the Neoclassicists, Delacroix wanted to appeal to viewers' emotions rather than to their reason. Ingres regarded Delacroix as a courier from hell. When he met the Romanticist he exclaimed: 'I smell sulphur!' However, around 1850 things calmed down for Delacroix: a new 'school of ugliness' had appeared on the stage—the Realists.

Critics were quick to proclaim the self-assured Gustave Courbet as the movement's leader. Courbet wanted to depict nature and people 'as they are'—realistic, faithful, modern (ill. 5). However, very few people regarded simply depicting one's environment as art. It was generally thought that a person who painted in such a manner was degrading himself, becoming a slave to reality, a witless worker, a brainless machine. A glance at the most widely read French book on aesthetics of the time shows this: Charles Blanc's *Grammaire des arts du dessin* (1867) was published just at the time when the Impressionists were attempting to establish themselves on the art market. According to Blanc, the only real masters were those who were able to approach an ideal form of beauty in their work. To achieve this, it was necessary to purify reality of any individuality and randomness and convert it into an ideal form, determined by the ideals of beauty of antiquity. Blanc's 'real masters' had to approximate, or even reproduce, ancient figures.

Roused like a swarm of bees, the critics reacted particularly fiercely when innovative artists like Delacroix and Courbet had the audacity to tackle history paintings, which were regarded as the 'elite division' of art. In keeping with their significance, these large-sized paintings (David's *Coronation of Napoleon I*, for example, measures 621× 979 cm) showed stories from the Bible, ancient myths, and heroic events from French history. Such pictures held unchallenged the first place in the rankings of the various types of painting, followed by portraits, genre painting, still-lifes, and landscapes (it was thought that less artistic skill was required for these subjects). History paintings fetched top prices and these artists were held in great esteem by the establishment.

However, several painters devoted most of their artistic lives to landscape painting, including Camille Corot (ill. 6) and the painters of the Barbizon School, an artists' colony which around 1840 had established itself in Barbizon, an area on the edge of the forest of Fontainebleau. Théodore Rousseau, Jean François Millet, Narcisso Virgilio Díaz de la Peña and Charles François Daubigny were among those who settled there. They were dedicated to 'truth towards nature' and worked *en plein-air*, out of doors, where they created oil sketches, true to reality.

Plein-air painting was boosted by an innovation of the time, the invention of the metal tube, which meant it was no longer necessary to transport paints in pigs' bladders, where they quickly dried out. Armed with these tubes of paint and portable easels, it now became possible for an artist to paint a picture entirely in the open air. Relatively few chose to do this: though their pictures appear simple and atmospheric, most of the Barbizon painters completed them in the studio. Daubigny (ill. 7) and Eugène Boudin (ill. 8), who often painted on the Normandy coast and was to become Monet's mentor, appear to be the only exceptions in the 1840s and 1850s. We have them to thank for the first genuine French landscapes painted out of doors.

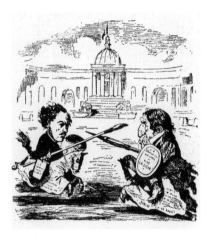

ill. 3
Caricature of Delacroix and Ingres in front of the Institute de France. *Delacroix:* 'Line is colour!' Ingres: 'Colour is utopia. Long live the line.'

ill. 4
Eugène Delacroix,
Christ on the Lake of Genesareth,
c. 1853, oil on canvas, 46.1 × 55.7 cm,
Portland, Portland Art Museum

As Delacroix had done, Corot, the Barbizon painters and Boudin also let their brushstrokes be seen. The critics, who regarded a smooth surface as a sign of mastery, reacted immediately: 'These painters could do no more than put a series of coloured patches next to each other—they were satisfied with a mere impression.' The future Impressionists were fascinated by all these artists who had 'gone astray': They acclaimed the effects made by the colours in Delacroix's paintings, their expression and passion.

Manet copied some of his pictures in order to decipher their 'secret', and Seurat made a painstaking study of the way the artist had placed colours alongside each other in order to achieve such luminosity.

Courbet's self-assured intervention for depicting reality using contemporary motifs played a role in the Impressionists' choice of subjects; Corot often painted out of doors with Pissarro and, later, with Berthe Morisot and her sister, advising them to 'follow their first impression'. All of these influences found their way into the works of the Impressionists, though, naturally, other models also played a role with individual artists—even Ingres, in the case of Degas.

ill. 5
Gustave Courbet,
The Young Ladies on the Banks of the Seine (Summer),
1856/57, oil on canvas, 174 × 206 cm,
Paris, Musée du Petit Palais

ill. 8
Eugène-Louis Boudin,
On the Beach at Trouville, 1863,
oil on wood, 25.4 × 45.7 cm,
New York, The Metropolitan
Museum of Art, bequest of
Amelia B. Lazarus, 1907

THE PUBLIC TOUCHSTONE—THE SALON

In nineteenth-century France, an innovative artist was confronted with many obstacles.
If he could not rely on his family for support or did not have an inheritance at his disposal,
it was difficult to survive. There were very few scholarships available and the few that existed
were granted to those who painted in the officially sanctioned style, in other words, in the
style of the painters admitted to the annual Salon, at that time the most important international
market for contemporary painting and sculpture, with as many as four thousand visitors a day
from France and abroad.

The Salon was a well-established tradition, having been founded in the seventeenth
century by Louis XIV. Originally, the work of the best pupils of the Académie des Beaux-Arts
had been shown in the Salon Carré of the Louvre, which gave the exhibition the name it kept
when it moved to the Palais d'Industrie in 1855.

In 1791, following the French Revolution, all artists were permitted to submit their work,
but the decision whether or not to exhibit paintings was reached by a jury consisting of
Académie professors and government officials. The avant-garde was not in favour: even if
an artist was fortunate enough to have his painting selected, he could not be sure that it
would be noticed by the visitors. Five thousand works were shown at the Salon held during
the 1855 World's Fair, the paintings hanging so closely together that their frames overlapped,
small ones overpowered by large-scale works (ills. 9 and 10).

The Minister of Fine Arts made purchases at the Salon for public buildings and museums.
If the state bought, then so did private collectors, assuming that if an artist had survived the
baptism by fire of the Salon and been ennobled by a purchase, then he simply had to be good.
There were very few other places for presenting paintings to the public until well into the
nineteenth century, when the first private galleries were founded.

All the Impressionists repeatedly applied to participate in the Salon in order to gain a
foothold in the market, though only Manet considered it to be the only suitable place to face
competition throughout his life. His six years of training with the famous history painter
Thomas Couture had given him hopes for a brilliant Salon career, but he left his teacher's
atelier dissatisfied, proclaiming defiantly: 'I paint what I see and not what others choose to see.'
Tramps and gypsies, for example, and Spaniards, marked the beginning of Manet's independent
work. Boosted by the rampant fashion for Spain of the time, which had set in with the marriage
between Emperor Napoleon III and the Spanish Duchess Eugénie, Manet's painting *Spanish
Singer* (ill. 11) was admitted to the 1861 Salon.

Two years later, Manet submitted similar motifs but even though Delacroix, who had
become recognised, spoke in his favour, the *Young Man in a Majo Costume* and *Mlle Victorine
in an Espada Costume* were rejected, as well as one other, more important painting:
The Lunch on the Grass (p. 32).

ill. 6
Jean-Baptiste-Camille Corot,
Souvenir of Mortefontaine, 1864,
oil on canvas, 65 × 89 cm,
Paris, Musée du Louvre

ill. 7
Charles-François Daubigny,
The Flood-Gate at Optevoz, 1859,
oil on canvas, 48.5 × 73 cm,
Paris, Musée du Louvre

In all, more than three thousand artists were rejected, and protest against the jury's decisions reached such proportions that the Emperor decided to take the matter into his own hands. He had a selection of the rejected pictures shown to him and gave instructions to organise a 'Salon des Refusés' (Salon of the Rejected). Participation was voluntary, but it was a tricky affair: Napoleon III wanted to prove the jury's competence; those rejected, the opposite, hoping that the narrow-mindedness of the jury would hit visitors in the eye.

However, most visitors fell for the Imperial tactics, amusing themselves greatly and deciding that the jury had been right. Meanwhile, at the 'normal' Salon, there was general delight over Alexandre Cabanel's *Venus* (ill. 12), a painting exactly to the taste of Napoleon III, who immediately purchased it for his private apartments. It showed a naked woman stretched out lasciviously, but while *Venus* was permitted to exhibit her uncovered body, her anonymous contemporaries in Manet's *The Lunch on the Grass* were forbidden.

Although Manet's naked woman did not come anywhere near the pulsating eroticism of Cabanel's *Venus*, the Emperor rejected the painting as being 'indecent', a word which was echoed by many of the visitors, who then dashed to the jam-packed 'Salon des Refusés' in order to see the painting for themselves and be outraged.

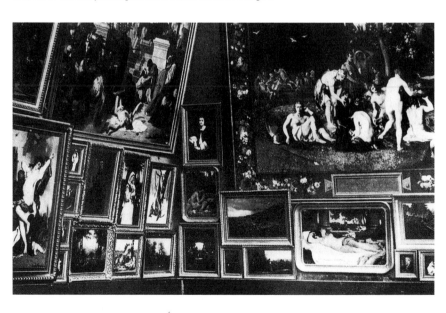

ill. 9
Presentation of the paintings in
the Salon of 1861.

There were people, however, including painters and writers, who did not take part in this hypocrisy, convinced that in this painting, as in Manet's first, strictly modern picture of the large city, *Music in the Tuileries Gardens* (ill. 13), an artist was at work who was ringing in a new artistic era. One year later, in 1864, the Salon rules were relaxed: only thirty per cent (instead of the former seventy per cent) of the submitted works were rejected—and, this time, Manet's was not. However, his *Olympia* (ill. 14) caused the usual uproar because it did not show a Venus or any other nude 'compatible' with the propriety of the day, but a prostitute, something which was obvious to the contemporary viewer. Even Manet's *Christ between the Angels*—a traditional motif—was subjected to negative comments: the body of Jesus appeared too realistic, 'like a miner pulled out of a coal pit'. On the other hand, there were complaints about the angels not being sufficiently 'lifelike', because of the blue feathers of their wings.

Owing to the inconsistencies and often undignified presentation at the Salon, Manet decided to organise a solo exhibition during the 1867 Paris World's Fair. Gustave Courbet had already risked the same in 1855. These activities provided the coming generation of artists with the encouragement and incentive to take organisation into their own hands.

MANET AND THE BATIGNOLLES GROUP

Manet's venture was discussed at length by the guests of the Café Guerbois, which was located in the Parisian district of Batignolles, where many avant-garde painters and writers lived. From around 1866, Manet had organised regular nightly meetings there; his admirers, including art critics, journalists and writers such as Emile Zola, Zacharie Astruc, Théodore Duret and Edmond Duranty, received first-hand information on his ideas about art, politics and society. There were discussions and arguments, some of which became heated: one day, Manet, who could not stand any contradiction, fought a duel with Duranty and wounded him, though they were reconciled again the very same evening amidst general applause and singing. Painters who admired Manet also visited the café.

One of the first was Edgar Degas, two years younger than Manet, who had made his acquaintance in 1861. Both men came from a well-off background, both were dyed-in-the-wool Parisians, men of the world, elegant and sharp-tongued. They had made a precise study of the works of the old masters and transferred their findings to the present. Rather than landscapes, their subject was the French capital and its inhabitants from different social spheres. Degas spent weeks observing ballet dancers while they were practising, tears and sweat on their faces, and singers during their emotional appearances in the cafés-concerts like *Singer with a Glove* (ill. 15), laundrywomen, washerwomen and ironers hard at work (p. 40), jockeys carrying the hopes of the spectators (p. 42). He made innumerable drawings, piecing the motifs together in his studio to create pictures which seem to have been captured directly from life.

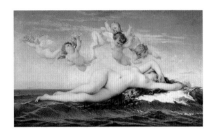

ill. 12
Alexandre Cabanel,
The Birth of Venus, c. 1863,
oil on canvas, 130 × 225 cm,
Paris, Musée d'Orsay

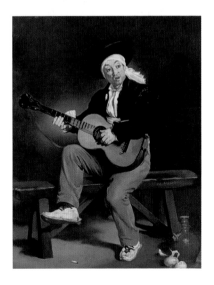

ill. 11
Edouard Manet, *The Spanish Singer*, 1860,
oil on canvas, 147.3 × 114.3 cm, New York,
The Metropolitan Museum of Art,
gift of William Church Osborn, 1949

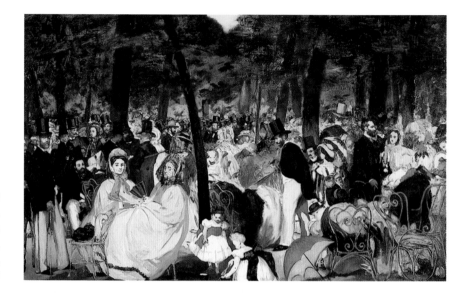

He showed certain aspects in a way which previously had not existed in the tradition of western art: his overlapping was abrupt (p. 42), his views from above and below exceptional (p. 44, above) and the narrow rectangular formats he sometimes used, unusual (p. 80). No other artist was as capable of integrating the new stimuli provided by Japanese woodcuts.

After the Japanese ports had been opened to international trade in 1854, prints by Utamaro, Hiroshige, Hokusai, and their pupils had gradually become known in Europe (ill. 16) and spread like wildfire throughout artistic circles in the second half of the 1870s.

All the Impressionists, not only Degas, found Japanese art a revelation. They were fascinated by its formerly unknown focussing and abstraction in spite of—or maybe precisely because of—the academically false spatial relationships.

Frédéric Bazille, a family friend of Manet's, soon joined the artists' group. He was the son of an affluent wine producer from Montpellier and had studied with the academic painter Charles Gleyre. He quickly befriended some of the other members including Auguste Renoir, the son of a tailor from Limoges and trained porcelain painter; Claude Monet, a hothead from Normandy, the son of a grocer, who as a student had already sold his succinct caricatures; and Alfred Sisley, the son of a rich English businessman who had settled in Paris, who discovered his enthusiasm for Turner and Constable during his apprenticeship in London (ill. 17). These four rapidly developed into a closely knit community, with Monet as the leader.

Thanks to the landscape painter Eugène Boudin, Monet had the most experience in *plein-air* painting, which the others were fervently interested in. Initially, Monet had not liked Boudin's paintings, though Boudin was impressed by Monet's talent as a draughtsman, having seen his caricatures exhibited in a shop in Le Havre. Though Monet was at first reluctant, Boudin insisted that they should paint together at the coast, persisting until Monet could no longer think of an excuse not to go. Boudin taught him to recognise the simple beauties of nature, showing him that pictures created outdoors 'always had a greater power, freshness

and liveliness in their brushstrokes than could be produced in the studio' and advising him to 'be persistent in preserving the first impression, which is always the best'. Johan Barthold Jongkind (ill. 18) soon joined the master and his pupil and was eternally grateful to Monet for having provided him with 'the ultimate training for my way of seeing things'.

Monet wanted to make Bazille, Sisley and Renoir aware of his intense experiences with *plein-air* painting. In 1863, under his guidance, they moved into the area which had inspired the Barbizon painters, the Fontainebleau Forest, laying the cornerstone for Impressionist landscape painting. Renoir and Monet built on this when they created their views of *La Grenouillère* (pp. 38–39), a country inn on the banks of the Seine, in 1869. Water, with its restless surface, its reflections, its fleeting reflexes of light, was just as inspirational for the Impressionists as snow. They gradually became aware that neither water nor snow, in fact no object at all, was ever seen in its 'genuine' colour; they realised that the way a colour appears is always dependent on lighting conditions and the colour of the surrounding objects. Snow, for example, is white but does not appear so because the shadows on it are always grey. They considered the 'colour' of the object to be a pure convention which had nothing in common with how the viewer actually perceived it. Renoir's and Monet's paintings of *La Grenouillère* (pp. 38–39) are among the earliest examples of Impressionist landscape painting where these observations are given a concrete form. They attempted to capture that which Monet described as 'the fleeting effect' of nature, something which was to become almost manic in his series of paintings (pp. 112–113, 118–119). Monet's specific concern was the light; the object itself was of decreasing importance.

One day, Camille Pissarro met the circle of friends in the Café Guerbois. He was older than Manet, radical in his views, receptive to innovations in art and a considerate and stabilising friend for the most difficult of characters, even for the particularly complicated Paul Cézanne. The son of a banker from Aix-en-Provence, Cézanne had left his law studies to pursue an artistic career, following his childhood friend Emile Zola to Paris in 1861 to take up his studies there. He often exaggerated his provincial, clumsy nature as a means of protecting himself in his unfamiliar surroundings. Searching and feeling his way, Cézanne was attempting the same as Pissarro, Manet, Degas, Monet, Bazille, Sisley, and Renoir: striving to find a personal, individual, expression. This was why the artists had become friends, this was the topic of the discussions of the Batignolles group—or, as they were also called, Manet's gang. And also the question: how can we show our work to the public? Is it possible to organise an alternative to the official art business? At that time, there were very few possibilities for exhibiting outside the Salon. The exhibition which Manet had organised in 1867 acted as an incentive for the Batignolles group. They were convinced that somewhere there were people who wanted to see and who would appreciate their art: they simply had to find a way of bringing their art to the public. The idea of forming a society in which artists, regardless of their style, could come together with the aim of organising joint exhibitions was born.

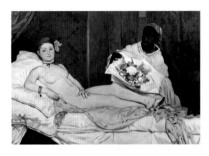

ill. 14
Edouard Manet, *Olympia*, 1863,
oil on canvas, 130.5 × 191 cm,
Paris, Musée d'Orsay

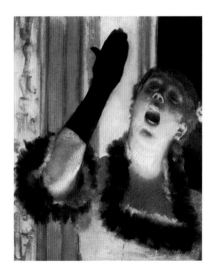

ill. 15
Edgar Degas, *Singer with a Glove*,
c. 1878, pastel on canvas, 52.8 × 41 cm,
Harvard Art Museums/Fogg Museum,
bequest from the Collection of
Maurice Wertheim, Class of 1906

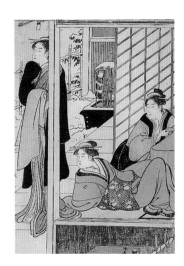

AN INTERRUPTION AND A NEW BEGINNING—THE IMPRESSIONIST EXHIBITIONS

The artists were forced to wait until 1874 to be able to implement their ideas: the Franco-Prussian War of 1870/71 put an end to the discussions in the café and the circle of friends scattered in all directions: Manet, Degas, Bazille, and Renoir were required to serve in the military, while Cézanne escaped the draft in Aix. Monet and Pissarro emigrated to London. Their faithful friend Frédéric Bazille was killed in action, but the others only suffered material losses: Manet's atelier was severely damaged, Pissarro's house in Louveciennes looted: only forty of the 1,500 paintings he had created in twenty years were saved. He received 835 francs in compensation.

Soon after the war ended, the artists returned, once again working in the Café Guerbois on their plans for exhibitions. Finally, on 27 December 1873 they were ready: the artists' society with the clumsy name *Société anonyme cooperative d'artistes peintres, sculptures, graveurs et lithographes* was launched. Its goal was to make it possible for each member, upon payment of a fee of sixty francs, to show and sell his works in self-organised exhibitions.

Interestingly, it was also prophesied in the café that the *Société* would fail because there were no restrictions to the works regarding style or aesthetic outlook. Indeed, this heterogeneity was apparent in the exhibition, which opened in April 1874 in the studio of the photographer Nadar, on the Boulevard des Capucines. Today, the majority of the thirty participating artists are forgotten; those who, after this show, were called Impressionists were in the minority. There was also a lack of common ground in the search for exhibitors: while Monet dreamed of a group of landscape painters working in a new technique, Degas was concerned that there would be an overabundance of works in a revolutionary style and feared that connection with them would mark him as a radical. For this reason, he attempted to persuade artists who were represented in the Salon to take part. One painter, who was important for all concerned, declined: Manet, whom the critics still proclaimed the leader of the Impressionists (ill. 19).

Around fifty Impressionist works were shown at the exhibition, by Cézanne, Degas, Monet—including *Impression, Sunrise* (p. 48)—Pissarro, Renoir—including *La Loge (Theatre Box)* (p. 58)—Sisley and Berthe Morisot, whom Manet had introduced into the Batignolles group, but very little was written about the show in the press, most critics refusing to attend as they considered the exhibiting artists amateurs. However, Louis Leroy ventured out and the result was the hatchet job entitled 'Exhibition of the Impressionists', which was published in the popular satirical magazine *Le Charivari* on 15 April 1874. This gave the artists the Impressionist label which was to develop into their trademark. In his article, Leroy invented a little tale. He described his visit to the exhibition in the company of a (fictitious) academically trained landscape painter called Joseph Vincent. According to the narrator, Vincent was initially harsh in his judgement: He found the legs of Degas' dancers to be like spiderwebs and had to polish his glasses in front of a Pissarro landscape because he thought they had misted up. Finally, he went mad, taking on the 'position of the Impressionists'. He thought that an exhibition

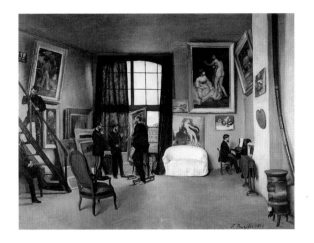

ill. 17
Frédéric Bazille,
Bazille's Studio; 9 Rue de la Condamine,
1870, oil on canvas, 98 × 128 cm,
Paris, Musée d'Orsay

attendant was a painting—'"Rather bad," he said, with a shrug of his shoulders. "His face has two eyes, a nose, and a mouth. The Impressionists would have paid less attention to the details. Monet could have painted twenty attendants out of what that painter wasted on the face."'
It comes as no surprise that after such a devastating lampoon, the artists had a mortal terror of the label Impressionists. However, the word which actually succeeded in describing their intentions in such a catchy and concise manner caught on and, within a few months, was established as the name of the new artistic movement. In hindsight, that was the only positive result of the exhibition. The attendance figures were devastating; the sales, just as bad. Almost all the participants were dissatisfied and the *Société* was dissolved in December.

The exhibition may have been a failure but nevertheless, after the war of 1870/71 the 'golden age of Impressionism' dawned, in which the style reached its peak. Most of the painters lived in Paris or in the surrounding rural areas, close enough to be able to reach the capital quickly by train. Monet had settled in Argenteuil after his return from London in 1871. Many of his friends from the Café Guerbois visited him there in the following seven years (pp. 54–55); even Manet, who thought that rural areas had nothing to offer him as a painter, came in 1874. It was the time when the 'king of the Impressionists' was studying his friends' techniques and making his attempts at a dynamic form of *plein-air* painting which, as a convinced studio painter, he had previously rejected. Among the works he created at the time are *The Boat*, a monumental depiction of a contemporary leisure-time activity, and *The Barque* (p. 52), where his technique clearly shows Monet's influence. Contrary to Manet, Monet liked to regard himself as someone who would not even consider painting in a confined space—indeed, he reacted with great indignation when a journalist requested to visit his studio: 'My studio! I have never had a studio, and I simply cannot understand how one can lock oneself into a room. Maybe to draw; but to paint, never. . . . Look, that is my studio!'—and he dramatically pointed to the landscape. Gustave Caillebotte, who had been introduced to the group by Degas, visited Monet, too. A man of independent means, he was a blessing for the impoverished artists, supporting them financially and buying their pictures. He had a lot to talk about with Monet— and not only about art: Caillebotte was a gardening fanatic and Monet was also turning into one. Wherever he settled, he turned his property into a blossoming work of art; after the mid-1870s, his gardens were to become his most important motif.

The artists gradually recovered from the disappointment of their first exhibition and reached the decision to make another attempt, this time, however, with professional support from an art dealer. Paul Durand-Ruel had represented most of the Impressionists for some time and was eager to have the new style accepted. He had even organised exhibitions of their

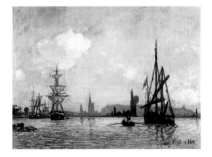

ill. 18
Johan Barthold Jongkind,
The Port of Rouen, 1865,
oil on canvas, 40.5 × 54.5 cm,
private collection

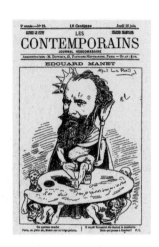

ill. 19
Cover of the journal
Les Contemporains:
Manet as 'king of
the Impressionists'

works in London and often helped them out of financial difficulties by buying all the paintings of a single artist, although he often had problems reselling them. This time, the critics' interest in the 'Exhibition of a Group of Artists' held in 1876 was somewhat greater, mainly, however, because they thought the art of the 'Impressionists' promised a certain amount of entertainment. The renowned, conservative art critic Albert Wolff wrote in *Le Figaro*: The artists 'take canvas, brushes, and paint, smear a bit of it around as they see fit and then put their signatures on it. That is exactly as if the poor inmates of the Villa Evrard [a psychiatric clinic] would collect stones from the roadside and think they were diamonds. It is a horrifying example of the futility of human endeavour: a form of self-delusion, bordering on insanity.' This exhibition was a financial fiasco.

Had it not been for Gustave Caillebotte, the series of exhibitions would have ended there: It was only his personal, generous financial commitment which made the third show in April 1877 possible. Stylistically, this was the most homogeneous of all the eight. Even though the artists did not like the 'Impressionists' label, the word appeared in the title of the exhibition. They had become reasonably well known under the name and it looked better than many of the others which had appeared in the press: 'the intentionalists', 'the stubborn', and 'telegram-style painters'. There was more publicity than ever before or after, posters were hung, newspapers contacted and their own magazine founded: Four issues of *L'Impressioniste* were published. The editor, Georges Rivière, finance official, writer, journalist and friend of Renoir, went into battle against the hostile critics, explaining the Impressionist style and attempting to convince the public of its relevance to the present time. However, despite all his efforts, once again 'peals of laughter, disdain, indignation, and disgust' greeted the paintings. This reaction is difficult for us to understand today when we look at paintings like Monet's *Saint-Lazare Station* (p. 72), Caillebotte's *Paris Street, Rainy Day* (p. 70), Renoir's *Dance at the Moulin de la Galette* (p. 66) and the bathers and still-lifes by Cézanne who, in this year, was exhibiting with his friends for the last time before withdrawing to the solitude of his homeland in Provence.

However, the Impressionists were justified in their conviction that there were people who appreciated their way of seeing things and painting. Gradually, their work was being discovered by admirers and collectors, most of whom came from the bourgeoisie, who had attained their wealth through trade and industry and were open to new ideas, less influenced than the nobility by the classical notion of beauty preferred by the Salon. The simple, everyday motifs of the Impressionists appealed to them more than pompous depictions of glorious battles and mythological or biblical stories.

The famous baritone Jean-Baptiste Faure, the owner of a chain of department stores Ernest Hoschedé, the customs officer Victor Choquet, the architect Jacques Le Cœur and the stockbroker (later to become a famous artist himself) Paul Gauguin, were among the first Impressionist collectors. When they were short of money, the Impressionists 'paid' others with their paintings: Eugène Murer, the owner of a patisserie and restaurant, for meals, Georges de Bellio, a doctor specialising in homeopathy, for medical treatment, and Jean Tanguy (ill. 20),

a paint dealer and paternal friend of the Impressionists, for painting materials. Tanguy attempted to resell the paintings he received in payment; after the Third Impressionist Exhibition, until 1895, his establishment was the only place in Paris where one could see Cézanne's works. He was also one of the first in the French capital to offer coloured Japanese woodcuts for sale. In spite of their supporters, the last months of 1877 and the following year, were difficult for the less well-off Impressionists. The art market was as static as the general economy; hardly anybody could afford to buy art—even Ernest Hoschedé, the department-store owner, who was obsessed with the works of the Impressionists, eventually went bankrupt and his collection was auctioned.

Renoir was the only lucky one: one of his pictures had been accepted for the Salon and was noticed by the publisher Georges Charpentier, who not only commissioned Renoir to paint his wife and children (p. 74) but also enabled the artist to make new acquaintances in a social sphere which had previously been closed to him. The Charpentiers could afford paintings and commissions; Renoir's style pleased them and his livelihood was assured.

The Fourth Impressionist Exhibition in spring 1879 marked the beginning of a period of compromise and the withdrawal of some of the friends. Degas had succeeded in having artists who submitted pictures to the Salon barred from the show. For this reason, Renoir did not exhibit, neither did Monet or Morisot. In addition to Pissarro, this exhibition of 'independent artists' consisted mainly of Degas' friends, including, for the first time, the American Mary Cassatt (p. 82) and Paul Gauguin, who took part in all subsequent Impressionist exhibitions. This fourth show was at last a financial success but, owing to the predominance of Realism, the critics showed little interest. Indeed, individual voices could be heard saying that Impressionism was already 'on the way out'.

Degas was interested in an additional self-organised exhibition. After years of prosperity, he was now obliged to sell his paintings, which he did with great unwillingness because he found it difficult to part with his work. However, an increasing number of former comrades-in-arms refused to participate in the fifth show, held in 1880. Cézanne, Monet, and Renoir submitted works to the Salon and, in accordance with Degas' regulations, they were duly barred from the Impressionist exhibition. The initial enthusiasm and belief that they could be successful in group exhibitions had dwindled. Owing to the Impressionists' lack of funds at the beginning of their careers, it had been a logical way of becoming known but now they were being given solo exhibitions in locations including the premises of Charpentier's magazine La Vie moderne, the Durand-Ruel gallery, and that of his competitor, Georges Petit. The bond between the group became weaker with the increasing recognition of some of its members. Although Caillebotte and Pissarro attempted to patch things up, it was not possible to get Renoir and Monet back on board: their work was only shown in the seventh exhibition in 1882 because Durand-Ruel contributed paintings from his own stocks. As a result, Degas did not participate, proud as he was of being independent of the Salon and art dealers.

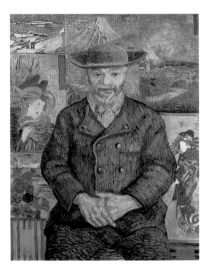

ill. 20
Vincent van Gogh,
*Portrait of Père Tanguy,
Half-Length*, 1887/88, oil on canvas,
92 × 75 cm, Paris, Musée Rodin

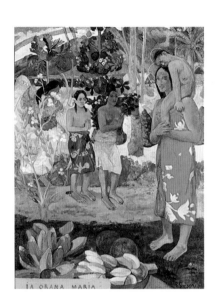

ill. 21
Paul Gauguin,
La Orana Maria (Hail Mary), 1891,
oil on canvas, 113.7 × 87.6 cm, New
York, The Metropolitan Museum of Art,
bequest of Sam A. Lewisohn, 1951

As with the previous exhibitions, this seventh one met with little interest from the critics. However, the eighth and final one was completely different, organised in 1886 by Berthe Morisot and her husband, Eugène Manet (the painter's brother). At this exhibition, Pissarro, who was always receptive to new ideas, succeeded in having works by Seurat and Signac accepted. He was enthusiastic about these young artists and displayed their paintings as works of a new 'scientific' Impressionism compared with the old 'romantic' form, explaining to the sceptical Durand-Ruel that 'mixing pigments (on the palette) must be replaced by optical mixing (in the eye). This optical mixing creates a much more intense luminosity.'

That was precisely what Seurat wanted and, with painstaking precision, he would cover his canvases with countless spots of pure, unmixed colour, a procedure he called Divisionism. His intention was to create something permanent out of the fleeting effects of Impressionism. The construction of his paintings therefore appeared to be classically rigid. Monet refused to participate, as did Renoir, Sisley, and Caillebotte; they were disconcerted by this new form of expression.

Seurat's large-scale work *A Sunday on La Grande Jatte* (p. 96) became the focal object of criticism. All of a sudden, the painter was catapulted into the centre of the avant-garde. In addition to the so-called Neo-Impressionism founded by Seurat and Signac, a style which would find its way into the history of art as Symbolism was gradually developing out of Impressionism. Its two most important representatives, Odilon Redon and Paul Gauguin, (ill. 21) took part in this eighth and last Impressionist exhibition.

INDIVIDUAL PATHS AND EFFECTS

Of course, this final exhibition was the end neither of Impressionism nor of the artists' friendship. However, some of the conditions which had made them such a tightly knit group no longer existed. Individually, they had become more or less established and no longer had the common goal of making themselves known to the public, and they missed the presence of their integrating 'leader' Manet, who had died after great suffering in 1883. A common focal point for their lives was gone. Monet had moved to Giverny, Pissarro to Eragny, Cézanne to Aix-en-Provence, places which could no longer be reached on a day trip from Paris. They still met regularly, though less often, and painted together, but their individual styles had started to diverge: for a period, Renoir even had doubts about Impressionism itself and orientated himself on Ingres. Monet's enthusiasm for light still gave him no rest and he painted increasingly extensive series (pp. 112–113, 118–119). Cézanne also repeatedly painted the same subjects— *Mont Sainte-Victoire* (ill. 22), fruit (p. 111) and his wife (p. 105)—but he wanted to achieve something precisely the opposite to what Monet was striving for: not to capture the fleeting moment but to track down and preserve the timeless.

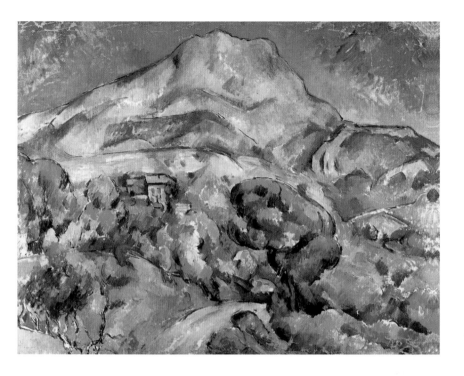

ill. 22
Paul Cézanne,
Mont Sainte-Victoire,
c. 1900, oil on canvas,
78 × 99 cm, St Petersburg,
Hermitage

Almost all the painters of the next avant-garde generations were influenced by the Impressionists and often began painting in their style. Although Vincent van Gogh, who had moved to Paris in 1886, did not initially share their radically new way of seeing and painting, he soon changed his mind. After a few months, he barred dark earth colours from his palette and began to experiment with the short, broad brushstrokes which were to become the bearer of the expression of his tormented inner life. Van Gogh sometimes applied his brushstrokes parallel to each other and sometimes lashed them dizzily onto his canvas (p. 103). This was the radicalisation of the Impressionist style about which the artist wrote to his friend Emile Bernard at the beginning of May 1888: 'My strokes do not follow any system. I cover the canvas with irregular blows which I leave where they are. Impasto, areas of uncovered canvas, completely unfinished corners here and there. Overpainting, roughness; in short, I would like to think that the result is quite disconcerting and annoying, so that it will make those people with a predetermined opinion on technique not feel very happy.'

The public recognition of Impressionism progressed rapidly. Monet, Manet, Pissarro, and Cézanne were represented during the 1889 World's Fair (where visitors gasped at the sight of the Eiffel Tower, at that time the world's highest structure) in the official art show, which presented an overview from Ingres to the Impressionists. Even Manet's scandalous *Olympia* (ill. 14) was exhibited and admired. Monet subsequently organised a public collection for the purchase of the painting from the artist's widow in order to present it to the nation. Despite bitter resistance from those close to the Ecole des Beaux-Arts, who even objected to *Olympia* being donated, the painting was soon hung in the former gallery for modern art, the Musée du Luxembourg, before finally reaching the sacred halls of the Louvre in 1907.

Although the specialised press applauded enthusiastically when it became known that Caillebotte, who died in 1894, had bequeathed his collection of Impressionist paintings to the nation, the Academicians once again reacted with disapproval. It was a long struggle for Renoir and Caillebotte's brother Martial to fulfil, at least partially, the last wishes of the artist. Not all the pictures were accepted, something which was later greatly regretted, for the market value of most of the Impressionists increased steadily. Around 1890, when a full professor at a university received a starting monthly salary of 225 francs and a stockbroker earned about 300 francs, works by Monet, Renoir, and Degas were being sold for 13,000 to 15,000 francs, though Sisley's landscapes rarely achieved more than 1,000 francs.

Faced with this development, the German Max Liebermann regretted having been so late in discovering the French Impressionists as objects for his collection. Now an influential art politician in Berlin, during his studies in Paris between 1873 and 1878 he had come into contact with the avant-garde—as did Corinth and Slevogt shortly thereafter—and had often visited the atelier of a painter from the Académie. At the beginning of the 1880s he already recognised Manet as a 'trailblazing genius', championing his work and that of the other Impressionists. Along with the director of the National Gallery, Hugo von Tschudi, Liebermann organised the purchase of a Manet painting (p. 79) for the museum and, jointly with the gallery owner Paul Cassirer and Lovis Corinth and Max Slevogt, put on exhibitions of the French Impressionists. In this way, the three artists, whose styles were greatly influenced by the Frenchmen, provided stimuli for many young German painters.

At the beginning of the twentieth century, Impressionism paved the way for a number of new styles which replaced each other at an ever-greater speed. All famous artists studied the last, long-living, avant-garde. Influenced by Gauguin and Cézanne—'a kind of good Lord of painting' (Matisse)—the Fauves moved from the Divisionist spot to level surfaces, experimenting with the effects of colour and form in their search for harmony within the picture. Monet, whose enthusiasm for the effect of light had rendered the object almost unimportant for him, inspired Kandinsky to completely abstract painting: When he could not recognise one of the Impressionist's *Haystacks* as such but nevertheless remained fascinated by the picture, Kandinsky realised that it was not essential for a painting to 'represent' something. Cézanne's experiments at painting objects from several viewpoints (p. 111) and his dictum to treat nature 'according to the cylinder, sphere and cone' spurred on Picasso and Braque, who developed Cubism. And not only did the future forms of the avant-garde draw on Impressionism: It became an absolute hit with the public in the twentieth century and the paintings achieved enormous prices at auction.

The Impressionist artists fought long and hard for the recognition of their art. They were deviated neither by ridicule nor miserable living conditions. Ultimately, Cézanne was proven right: 'Time and consideration will gradually change the way of seeing and, in the end, we will achieve understanding.'

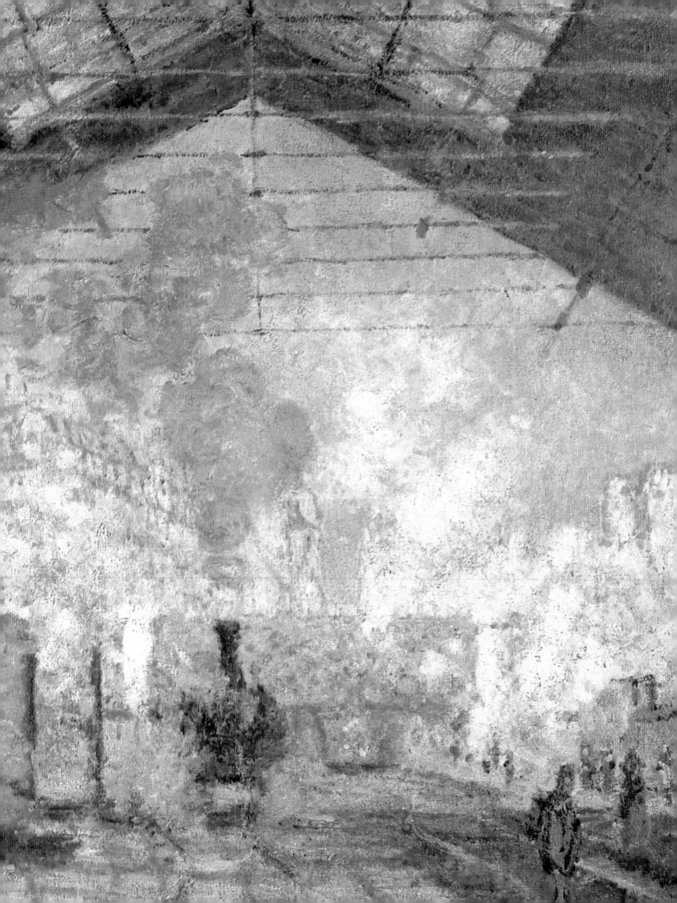

50 PAINTINGS

YOU SHOULD KNOW

EDOUARD MANET
The Lunch on the Grass, 1863

The jury of the 1863 Paris Salon, the most important exhibition of contemporary art, excluded more than two-thirds of the artists who had submitted their works from participating. The result was a great deal of discontent. Finally, Emperor Napoleon III, though he did not have much idea about art himself, conceded to demands and these works were exhibited to the public in the 'Salon des Refusés' (Salon of the Refused). Seven thousand visitors were recorded on the opening day alone—more than had attended the official Salon. The majority were looking for a sensation, eager for cheap entertainment. Manet's *The Lunch on the Grass*, which was exhibited as *Le Bain (The Bath)*, was unmatched in provoking ridicule and widespread perplexity: What was this naked woman, sitting next to her casually strewn clothing, supposed to signify? What about the two gentlemen, wearing tightly buttoned-up, fashionable clothes, who were stretched out nonchalantly near her? A simple picnic? A small, unobserved basket has been tipped over, producing a seemingly randomly arranged still-life of a bottle, fruits of the various seasons and bread rolls—a detail that was repeatedly praised by the critics.

In this painting, Manet is not concerned with telling a story or even hinting at one. Female nudes, erotically lolling about—as in Cabanel's *The Birth of Venus* (p. 17)—were always eagerly seen and admired but this was only when their nakedness was hidden behind the hypocritical, mythological or biblical story which gave the picture its title. Though these tales were often unknown to the visitors of the period, the accompanying brochures of the Salon provided explanations. However, in Manet's case, if he had called his painting 'untitled', it would have been no less enigmatic. In addition, the beauty did not hide herself in shame but had the audacity to stare at the viewer—what decent woman would do that?—as if she were unaware of her nudity, or else maybe all too aware of its effect. There was general agreement: as with *Olympia* (p. 19), she could only be a prostitute. Placing a person like that so prominently, right near the centre of a painting—simply shocking!

If the visitors to the 'Salon des Refusés' did not already disapprove of the strange subject matter, the inconsistent painting technique would certainly have earned their criticism. Manet's 'lurid way of painting cuts into the eye like a steel saw; his figures are cut out as if by a punch, with a brutality which is not eased by any form of compromise', was the way E. Chesneau criticised the painting in *L'Artiste*. Why did Manet not treat the surface of the painting uniformly, as was the custom of the recognised and popular artists? Elements which he regarded as important—the trio—stand out in their harsh illumination and are painted with great care. But what about the background? The foliage, the water and the woman modestly lifting up her bathing costume, appear to be dashed off cursorily. The audience must have been amused or silently bewildered by this painting which had no intention of satisfying conventional expectations.

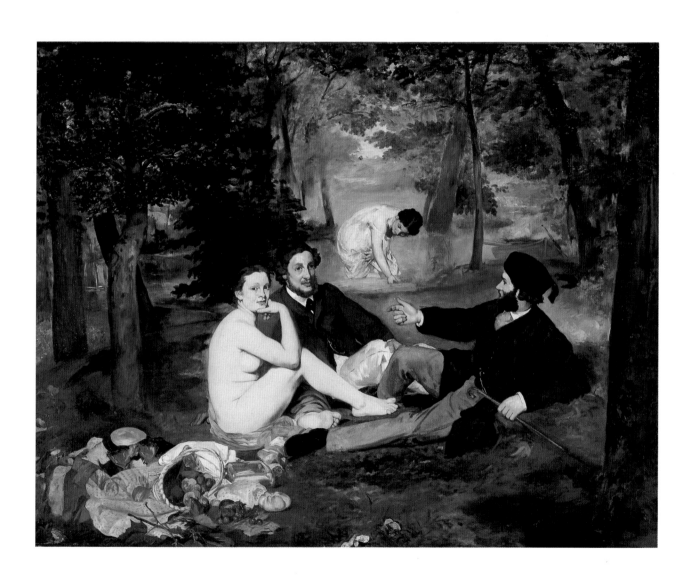

The Lunch on the Grass, 1863, oil on canvas, 207 × 265 cm,
Paris, Musée d'Orsay

CLAUDE MONET
Women in the Garden, c. 1866

Camille or *Woman in a Green Dress*, 1866, oil on canvas, 231 × 151 cm, Bremen, Kunsthalle

Monet had recently enjoyed great success with his contribution to the 1866 Salon: his *Woman in a Green Dress*, a fairly conventional studio portrait of his girlfriend, the nineteen-year-old Camille Léonie Doncieux, had met with general approval. In April, Monet rented a house with a garden near the Ville d'Avray railway station in Sèvres, to the south-east of Paris and began working on a large-scale painting of people in the open air, a motif he was particularly fond of. Camille was the model for three of the figures.

The demanding format of the more than 2.5-metre-high painting was cumbersome, in the real meaning of the word. In order to paint the upper sections without having to balance on a ladder, Monet had a pit dug, into which he could lower the painting using a rope and block and tackle. Gustave Courbet, who occasionally visited him, was amused by this open-air construction. They spoke a great deal about their work without always being of the same opinion—for example, Courbet, one generation Monet's senior, could not understand why he would only work on foliage when the sun was shining. But Monet remained unfazed. He had discovered the major subject of his entire artistic life: the depiction of light, as it really existed.

This is clear—or even too clear—in the *Women in the Garden*. He is neither interested in modelling the bodies nor characterising the women: they appear as stylised as the fashion displays of the time, making the varied lighting appear even more prominent. Patches of light hover about the clothes of the two figures on the left. The harsh shadows of the seated woman stand out and her face is only illuminated by the blue reflection of her dress. The contrasts between the sunny and shadowy areas are extreme; Monet is still uncertain, still a seeker in the field of light.

Monet was forced to leave Ville d'Avray in late summer. He had to flee from his creditors (not for the last time) and supposedly slashed almost 200 paintings so that they would not fall into the hands of his money lenders. However, even the remnants were turned into cash: bundles of fifty pieces were sold for thirty francs each. Monet's financial problems were so great that he could no longer afford to buy working materials. More than once, he scraped the paint off older paintings in order to obtain canvas for new, more important ones. His ambitious *Women in the Garden* survived all these actions unscathed: He intended to display it at the 1867 Salon. But the jury's decision was shattering: 'Rejected!' However, by 1921, he had become a recognised artist and the French state expressed its interest in *Women in the Garden*. Monet demanded 200,000 francs, and received it—revenge for the previous humiliation.

Women in the Garden, c. 1866, oil on canvas, 255 × 205 cm, Paris, Musée d'Orsay

03

CLAUDE MONET
Garden of Saint-Adresse, 1867

There is never any sign of the difficult times or serious pressures of Monet's life in his paintings. Working feverishly, he had the ability to forget about everything, to suppress his anxiety.

When he returned to the home of his childhood and youth in summer 1867, not only was his financial situation strained, but also the relationship to his family. In a letter to Monet's father, the artist's friend Bazille made a strong plea that he continue to support his son: Claude's partner Camille was expecting a baby. Neither had any idea of how they could provide for it. The future grandfather's answer was harsh: His son knew what he had to do—leave Camille! Only his Aunt Lecadre in Sainte-Adresse would help Monet, offering to provide him with shelter and pay for his food, but no more. Monet decided to accept her offer, leaving Camille in Paris, penniless and at an advanced stage of pregnancy. Shortly before the birth of his son, he wrote to Bazille: 'Here, everything is fine, both with my work and with the family. If it weren't for the birth, I would be as happy as a man could possibly be.'

During the summer, Monet painted this radiant day. His relatives are enjoying the sun and the breeze, sitting under the fluttering flags of the flowery terrace, with its view of the sea. Seated next to Monet's father, we see his aunt, Sophie Lecadre, an amateur painter who often put in a good word to help along her nephew's artistic career. In the background, the artist's cousin, Jeanne-Marguerite, is chatting with an unidentified man. Monet had set up his easel at a slightly raised position. He painted the ships and boats on the horizon with the same precision as the people on the canvas; the towering gladioli, geraniums, and nasturtiums in the foreground are created with casually placed, dazzling patches of paint. The individual objects on a single plane of the painting are treated differently: The easy, fresh handling of the flora and sea are an indication of Monet's future style, no longer a depiction of reality, but an image of it as seen through the eyes of Claude Monet. The artist later recalled that the work was regarded as being avant-garde and 'very daring'.

At the beginning of winter, Monet finally returned to Paris. He went against his father's wishes, moving in with Camille and his son Jean, who had been born at the beginning of August. A little less than three years later, Claude and Camille married with Gustave Courbet as best man, although Claude's family was still opposed to the alliance. In her short life, Camille remained faithful to Monet during good and, much more frequently, bad—even wretched—times.

Garden of Saint-Adresse, 1867, oil on canvas, 98.1 × 129.9 cm, New York, The Metropolitan Museum of Art, purchase, special contributions and funds given or bequeathed by friends of the museum, 1967

04 EDOUARD MANET
The Balcony, 1868/69

A beautiful woman in a white dress is seated on a balcony with a small dog at her feet. Magically, she draws all gazes towards her. She does not reciprocate: Her clear eyes absently watch the anonymous actors performing the never-ending play of 'life in the big city', as if she were seated in a box at the theatre. They are all strangers to her, as are the people with her on the balcony and those in the apartment behind it. In the confined space they are close to one another but they all look in different directions; they have no common interests. They remain alone with their private wishes, dreams and problems.

Manet said that it was difficult to paint a single person. 'But it's child's play to paint two (or, in this case, several) figures whose appeal comes through the interaction of their personalities.' Only in this way could he depict the characteristic, modern solitude, despite the physical proximity, of the city's inhabitants; this applies to his *Nana* (p. 69), *In the Conservatory* (p. 79) and *A Bar at the Folies-Bergère* (p. 89). Contemporary critics often accused compositions of lacking cohesion, which, although intended to be negative, in this respect becomes a form of praise. The pictures are open; they do not tell a story as was usual at the time, but challenge the viewer, even leaving him confused.

The completed painting, which was exhibited in the 1869 Salon, was disconcerting—even for Berthe Morisot, who had posed as the woman who, while observing, allows herself to be observed. She wrote to her sister Edma: 'I appear quite strange and ugly.' The young painter, Manet's future sister-in-law, appears here for the first time in one of his paintings. Of course, she had always been accompanied by her mother to the fifteen sittings in Manet's studio, along with the cellist Fanny Claus and the landscape painter Antoine Guillemet. However, these two were painted less finely by Manet and appear strangely two-dimensional, paling in comparison with Morisot. The fourth person attracts even less attention: Léon Koëlla-Leenhoff, the son of Manet's wife Suzanne Leenhoff and, probably, of the painter, almost disappears in the semi-darkness of the apartment.

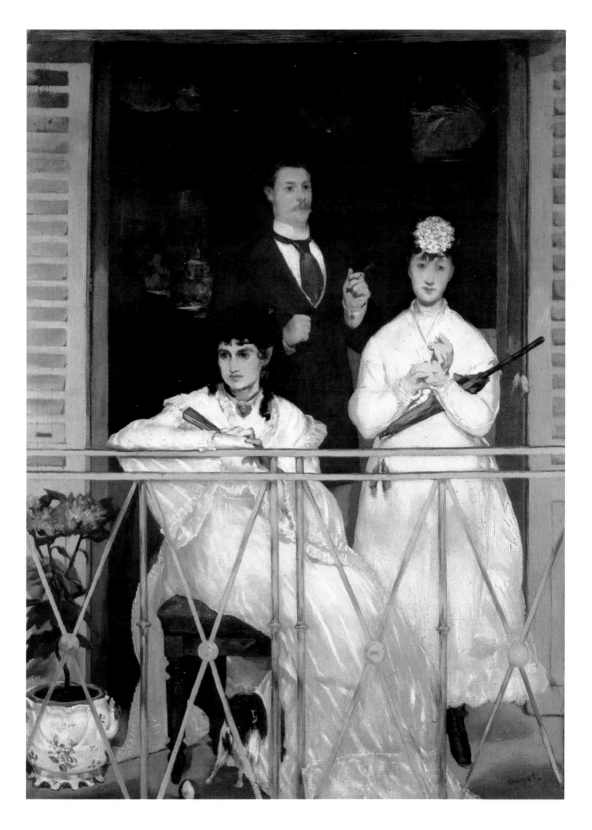

The Balcony, 1868/69, oil on canvas, 170 × 125 cm, Paris, Musée d'Orsay

05 CLAUDE MONET
La Grenouillère, 1869

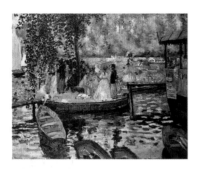

Auguste Renoir,
La Grenouillère, 1869,
oil on canvas, 66 × 81 cm
Stockholm, National Museum

On pleasant summer days, Parisians swarmed out to the tranquil villages which lined the Seine to the north-west of the city. It was only a twenty-minute train ride from Saint-Lazare Station to Chatou, where ferries connected the chain of islands in the Seine between Chatou and Bougival. La Grenouillère lay anchored by one of these islands: 'The gigantic raft is covered with a tarred roof supported by wooden columns; it is connected to the island of Croissy by two piers, one of which leads into the centre of the floating restaurant and the other to a tiny island with one tree on it,' was the way Guy de Maupassant described it. La Genouillère was one of the numerous *guignettes*, or open-air cafés, visited by day-trippers; a meeting place for coquettish maidens, the demi-monde, bourgeois men and women, artists and writers; a place where French society, in a manner of speaking, had a rendezvous. Renoir wrote, recalling the less than impeccable reputation of the idyll: 'The name Grenouillère, "frog pond", does not come from the numerous amphibians which inhabit the neighbouring meadows but from completely different "frogs": Women who were not particularly careful about their virtue were also called "frogs". They were not exactly prostitutes but belonged more to that group of young girls whose moral codes were typical of contemporary Paris. They changed lovers frequently, took what they felt like at the moment and sometimes even exchanged a villa on the Champs-Elysées for an attic in Batignolles without giving it too much thought.' Even Emperor Napoleon III and his wife Eugénie were curious to see La Grenouillère and visited the restaurant along with their court in the year in which the painting was created.

The twenty-eight-year-old Renoir painted this place of amusement several times in August 1869, side by side with Monet, who was one year older. The artists were living not far from each other during that summer and often met, as they did in following years, to paint, compare their work, and give each other advice. Renoir was particularly happy about the almost daily meetings 'because, when it comes to painting, Monet is good company'. Seeing the miserable financial situation of the Monet family, Renoir also helped where he could. Monet wrote: 'Renoir brings us bread, so that we don't starve. We'd had no bread, no fire and no light for eight days.' The portrayal of the cheerful day-trippers and the pleasant atmosphere give no hint of Monet's empty stomach and his rapidly dwindling supplies of painting materials. He captured the reflections of the rippling waves magnificently, his eye and speedy brush completely devoted to the scene. The bathing guests are of secondary importance: simple patches of colour are enough for them. Renoir was completely different: his endless enthusiasm for attractive clothing is demonstrated by the detail of the breezy summer dresses. The two painters use the same motif to show where their main interests in painting will lie: Monet, enthralled by the landscape of the city and nature; Renoir, by the portrayal of people.

La Grenouillère, 1869, oil on canvas, 74.6 × 99.7 cm, New York, The Metropolitan Museum of Art, H. O. Havemeyer Collection, bequest of Mrs H. O. Havemeyer, 1929

06 EDGAR DEGAS
Woman Ironing, c. 1869

A woman looks up from her work at the ironing board. Has she become aware of the viewer? Her gaze is empty. She pauses in her movements; the iron is placed on a fine, floral fabric. She still has more work to do: There is clean laundry drying over her head, and soiled, which will soon hang in its place. Her work is wearisome and exhausting; no ironing woman ever came up with the idea, as Degas did, of saying: 'Whenever I have not worked for a couple of hours, I get pangs of conscience and feel stupid and worthless.'

The work was tortuous, particularly in summer. The already sticky air in the backyards became even more intolerable in the working rooms: The coke ovens had to be kept roaring so the irons did not become cold. In his novel *L'Assommoir*, Emile Zola wrote: 'The temperature was murderous. The laundry, hung up to dry on copper lines, steamed and was as dry as sawdust in less than three-quarters of an hour. An abysmal silence reigned in this room with the humidity of a furnace in which only the dull thud of the iron could be heard making its way across the thick blanket covered with calico.' A washerwoman 'squatted on the ground and was busy starching the laundry. In a white petticoat, her naked arms could be seen in the rolled-up sleeves of her vest, which had fallen down from her shoulders, her neck was naked and she was so ruddy and sweated so much that the blond locks of her dishevelled hair were stuck to her skin.'

This breach in the bourgeois clothing etiquette attracted men. Keen to catch a glimpse of naked skin, they would stop in front of the laundries and gawk. Naturally, the working women had more pressing problems than worrying whether or not their clothes were properly in order: They had to provide for their families and, therefore, had to be quick and efficient. Many of them were forced to prostitute themselves in order to make a little extra money. For this reason, ironing women, along with the dancers and cabaret singers whom Degas frequently portrayed, were often regarded as being easy game. At the time of their creation, the subject of Degas' paintings gave them an air of the erotic and suggestive.

In the mid-nineteenth century, about one-fifth to a third of the women in Paris laundered clothes they themselves would never be able to afford. Emma Dobigny, whom Degas portrayed in this painting, was sixteen or seventeen years old at the time and a professional model.

In this first painting of an ironing woman, the painter concentrated on the individual, whereas in the many paintings which followed, up until 1902, he was more interested in the actual working procedure.

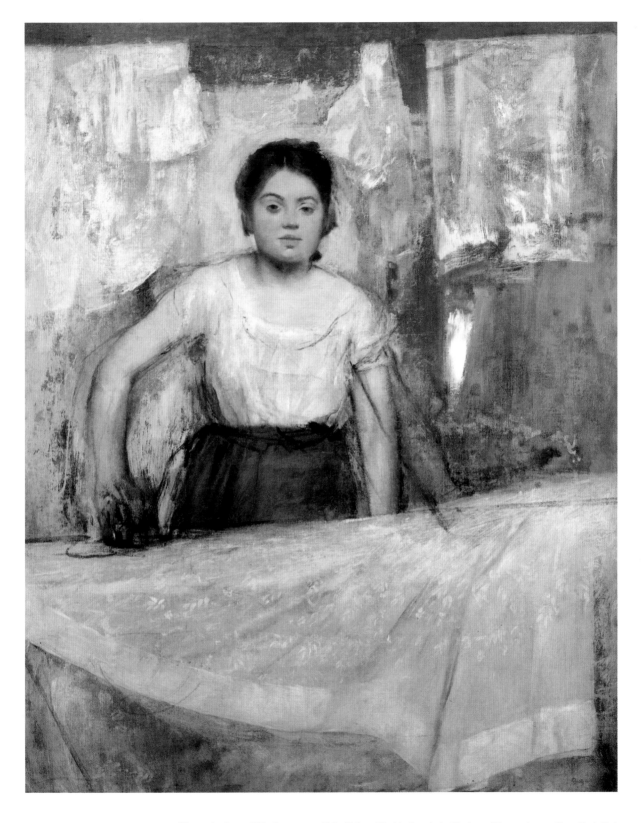

Woman Ironing, c. 1869, oil on canvas, 92.5 × 73.5 cm, Munich, Bayerische Staatsgemäldesammlungen, Neue Pinakothek

07

EDGAR DEGAS
Racehorses at Longchamps, 1871

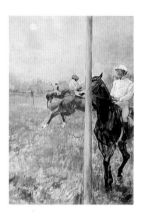

Jockeys Before the Race, 1879,
oil, essence, bodycolour and
pastel on paper, 107.3 × 73.7,
Birmingham, Barber Institute of Fine Arts

The racetrack at Longchamps, in Paris, was erected on the site of an abbey which had been destroyed during the French Revolution. It was opened in 1857 in the redeveloped Bois du Bologne and, with its elegant grandstands and parking places for carriages, was regarded as being one of the most beautiful hippodromes in Europe. Around the middle of the century, horse racing, which had been imported from England, was still seen as an extravagant pastime for the affluent upper classes. 'The races' had rapidly become one of the most important social events and Manet and his friend, Degas, who descended from the aristocratic de Gas family, were often seen there. Degas' interest in horses had been awakened during a stay in Normandy, where he had visited his friends, the Valpinçons. They bred horses themselves and the most famous French stud farm of the period was not far from their country seat. After 1860, the artist devoted himself to the subject.

Degas almost exclusively depicted the less eventful moments at the racetrack: the preparations before the start, the tranquil, albeit tense moments shortly before it. He was not interested in the dynamism of the race itself. He created the feeling of fleeting glance, with compositions which were usually not orientated towards the centre, with a rigorous isolation of figures and daring overlapping—methods to which he was inspired by Japanese woodcuts. However, although they appear to be like snapshots, none of Degas' pictures was actually created directly in front of the object—neither the surprised *Woman Ironing* (p. 40), nor the dancers, still with sweat on their brows from their training, rubbing their sore ankles (p. 45), nor the racetrack. He would produce numerous sketches and then construct his paintings from them, taking artistic, not documentary, aspects into consideration: Even the jockeys' silks are chosen at random. According to the master: 'A painting is, first and foremost, the product of an artistic fantasy. It must never be a mere imitation. Nothing can be said against the artist's including two or three things seen in nature in his pictures. . . . In any case, it makes more sense to draw from memory, when one is no longer in front of the subject. Then the powers of imagination provide assistance; one only includes that which impresses on the canvas—in other words, the absolutely essential.'

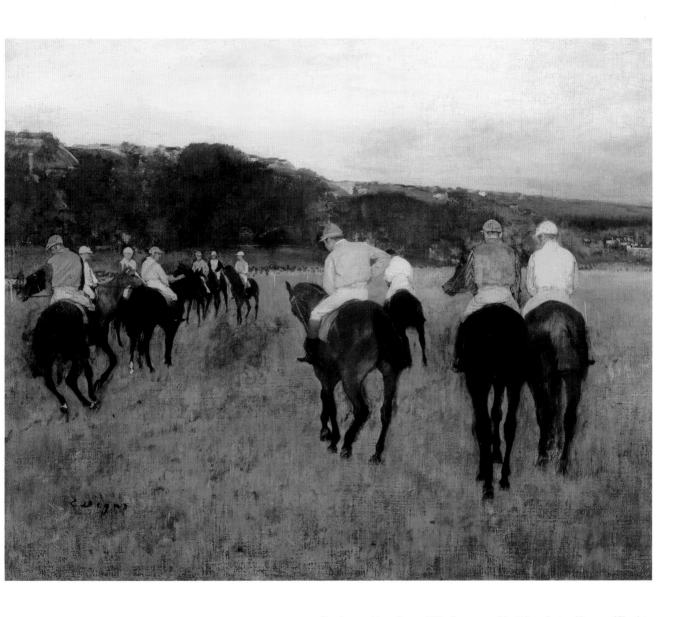

Racehorses at Longchamps, 1871, oil on canvas, 34 × 41.9 cm, Boston, Museum of Fine Arts,
S. A. Denio Collection—Sylvanus Adams Denio Fund and General Income

08 EDGAR DEGAS
The Dancing Class, c. 1871

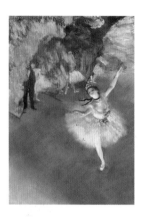

Ballet, c. 1876,
monotype pastel, 58.4 × 42 cm,
Paris, Musée d'Orsay

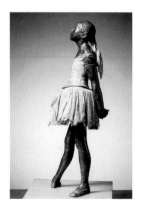

Little Dancer of Fourteen Years,
1921–31 (original work exhibited in 1881),
bronze cast 1922, 98 × 35.2 × 24.5,
Paris, Musée d'Orsay

The young ballet students of the Paris Opéra were called 'rats': They were usually hungry and rarely turned down something to eat. They often came from an impoverished background but were driven by hope: They hoped to pass the examinations of the strict ballet masters and thereby increase their salaries; they hoped, one day, to float across the stage as prima ballerinas; they hoped to find somebody who would 'discover' and support them. However, in order to fulfil all these dreams, the girls were subjected to strenuous daily training—back-breaking work, though this should not be noticeable during a performance. *Ballet*, with her fluttering ribbon, sails across the stage like a magical butterfly, liberated from the forces of gravity, in the harsh illumination of the stage lighting. These fresh young girls were particularly attractive to the type of mature, well-to-do gentlemen who often loiter around in Degas' pictures. In *Ballet* it is the man dressed in black, waiting in the wings. The subscribers to the opera could flirt with the dancers, charm their watchful mothers and manipulate the situation to their own benefit—that was all part of the opera world of the time.

Degas showed pain and triumph in many paintings. He is famous for his dancers but they did not interest him as individuals: For the artist, they were merely 'an excuse to paint flimsy fabric and depict movement'. In order to capture these movements so precisely, to show each fibre of muscle, to feel each quirer, the artist spent weeks and months behind and in front of the sets of the Opéra, in the rehearsal and coaching rooms, in the boxes and orchestra stalls, behind the musicians. Nothing escaped his unerring powers of observation. Time and time again, the obsessed artist captured the dancers, dance masters, and musicians on paper. The paintings were then produced in his studio, like snapshots. 'He knows how to compose without it appearing to be a composition,' wrote Max Liebermann, who admired this talent of Degas'. Every detail of the room, as well as the dancers, is carefully composed in a great variety of positions. Just as the girls polish their expressions and poses to become part of a work of art during the performance, Degas does the same with his pictures. 'Inspiration, spontaneity and temperament are unknown to me.'

His approach to the only sculpture he was to exhibit during his lifetime is just as reserved. When the model was displayed in 1881, the critics found it much too realistic, railing that it was a 'blossom of precocious depravity', a 'young monster' with a 'dissolute face' full of 'animal shamelessness'—but was it not precisely that which the 'supporters', the fans in the wings and the gentlemen in their top hats, secretly longed for? In spite of the reputation of these ballet 'rats', they were the most popular subjects for the collectors of the day.

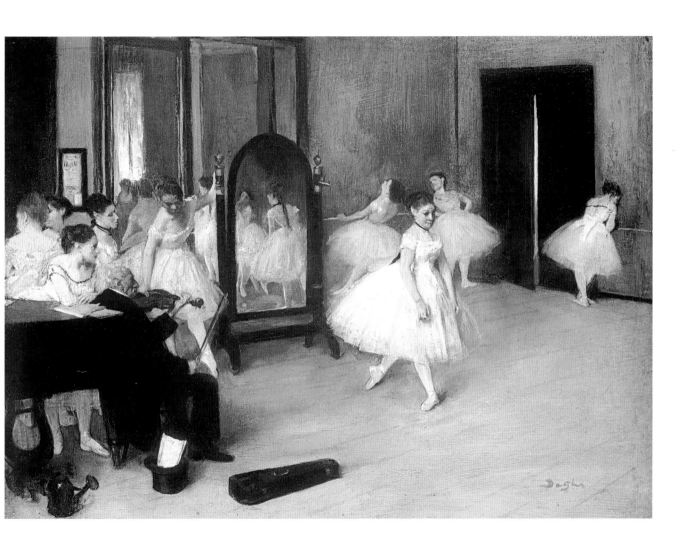

The Dancing Class, c. 1871, oil on canvas, 19.7 × 27 cm, New York, The Metropolitan Museum of Art,
H. O. Havemeyer Collection, bequest of Mrs H. O. Havemeyer, 1929

09

ALFRED SISLEY
The Bridge at Villeneuve-la-Garenne, 1872

Alfred Sisley's father was an English businessman who lived in Paris, where he owned a very successful silk shop. He wanted his son to follow in his footsteps and Alfred was sent to London for his apprenticeship, but instead of bookkeeping and calculations, it was the works of John Constable and William Turner in the museums which fascinated him. Although he completed his training, he realised that he wanted to become an artist and when he told his parents of his plans they placed no obstacles in his path.

During his artistic education in Charles Gleyre's studio, Sisley became acquainted with Renoir, Monet, and Bazille. He lived near Argenteuil and often visited Monet after the artist had moved there. They painted together, often joined by Renoir and Caillebotte; their discussions about their work helped them discover their individual styles.

Alfred Sisley was purely a landscape painter. The lively atmosphere of the cities provided no motifs for him, nor did the pleasures his contemporaries found on the banks of the Seine, although the places where he lived—Louveciennes and Marly-Le Roi, to the west of Paris— were close to the popular country inns they often painted (p. 38–39).

For this picture, Sisley travelled up-river to Villeneuve-la-Garenne to paint its new bridge. In this painting, as was so often the case, he gave a great deal of space to the sky because it 'not only gives the picture depth through its various layers but also provides its sense of movement'. The small clouds appear to be moving from left to right; the Seine is flowing in the opposite direction. He creates a perfect picture of the surface of the water, the glittering light and the sombre shadows, using short brushstrokes of different colours. The cast-iron bridge stabilises the contrary movements of the river and clouds in this clearly composed painting.

In spite of what the art critic Duret called his 'decorative sense', Sisley's picturesque works found few admirers. Hoping for sales, he took part in four Impressionist exhibitions, only to be disappointed each time. Throughout his life, he had difficulties providing for his wife and two children and inherited almost nothing from his father, who had been ruined as a result of the Franco-Prussian War. Even after most of his painter friends had established themselves, Sisley remained poor, as did Pissarro, who wrote: 'Sisley and I form the rearguard of Impressionism.'

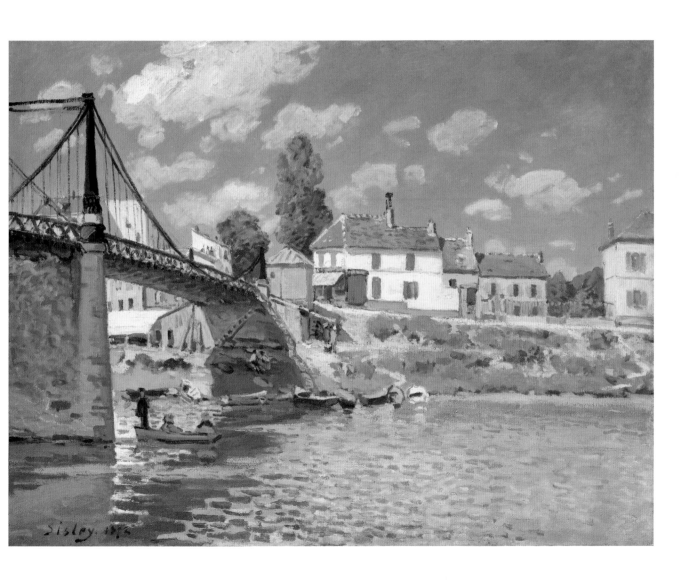

The Bridge at Villeneuve-la-Garenne, 1872, oil on canvas, 49.5 × 65.4 cm, New York, The Metropolitan Museum of Art, gift of Mr and Mrs Henry Ittleson Jr, 1964

10

CLAUDE MONET
Impression, Sunrise, 1873

On 25 April 1874, the satirical journal *Le Charivari* published a review by the critic Louis Leroy. Under the title of 'The Exhibition of the Impressionists', he wrote an imaginary dialogue between the author and the academic painter Joseph Vincent, thus coining the name of the new style. '"Here it is, here it is!" he exclaimed, in front of painting number 98. "What does this canvas depict? Look in the catalogue, *Impression, Sunrise*. I was not quite sure about it! I had just told myself that this must be an impression, because I am impressed. . . . What freedom, and what lightness in the execution! Wallpaper in its original state is more perfect than this seascape."'

Monet's painting *Impression, Sunrise* became famous as the name-giver for the Impressionist movement. Along with others of his seascapes, it had been created in Le Havre in 1872. Steam, fog and smoke from the chimneys make the back- and middle ground flow into each other. The day breaks light and airy: the strength of the sun will soon disperse the fog and give a clear view of the rather unromantic docks. Only the sun and its reflections are applied thickly and solidly, everything else appears to be as fleeting as the morning weather, everything amalgamates—even the sailors appear to be as light as shadows. Only the viewers' imagination makes it possible to discern the freighters and the docks.

Monet showed himself to be fascinated by 'indistinct' painting in London in 1870/71, where he had fled to avoid military service in the Franco-Prussian War. He made regular visits to the museums with his painter friend Camille Pissarro, whom he had once again met. They were enthusiastic about the works of John Constable and, particularly, William Turner, who had depicted the atmospheric interplay between light, water and smoke in increasingly abstract paintings from the 1830s to the 1850s. Art criticism, which was accustomed to making its judgements based on lucidity—as was the case in France—was forced to evaluate such paintings as well as Monet's *Impression, Sunrise*.

However, even under the most difficult circumstances, Monet demonstrated a lifelong, incredible resistance to criticism—to the benefit of his art. Renoir recalled his reaction to the negative judgement of *Impression, Sunrise*: 'Monet shrugged his shoulders: "Those poor blind people want to see everything clearly in the fog!" A critic explained to him that fog was not a motif for a painting.This lack of understanding provided an irresistible instigation for Monet to paint something much more foggy.' He chose the Saint-Lazare railway station (p. 72).

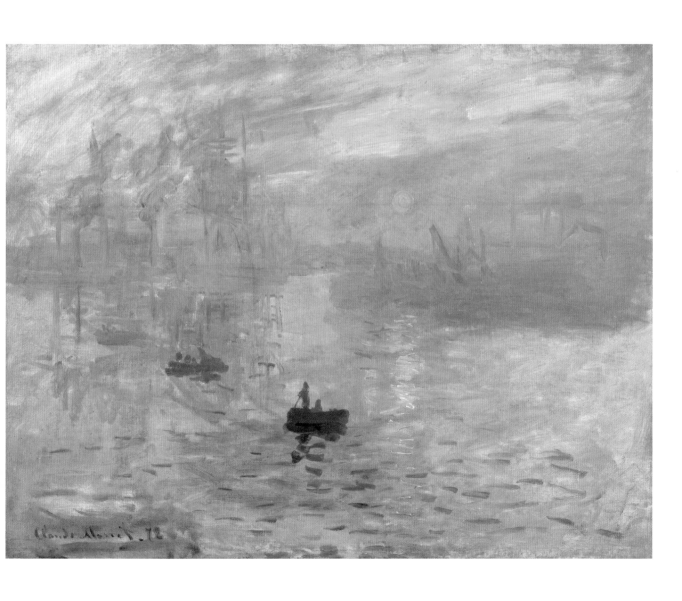

Impression, Sunrise, 1873, oil on canvas, 48 × 63 cm, Paris, Musée Marmottan

11

CLAUDE MONET
Poppies, 1873

Jean Monet on his Hobby Horse,
1872, oil on canvas, 60.6 × 74.3 cm
New York, The Metropolitan Museum of Art,
gift of Sara Lee Corporation, 2000

In 1872, Claude Monet moved with his wife, Camille, and son, Jean, to Argenteuil, at the time a small, pretty village on the Seine. It was only about fifteen kilometres from the Saint-Lazare station (p. 72) and there was a train every hour. The city was famous for its sailing regattas and asparagus (though one should avoid the wine!); in the 1870s, despite the beginning of industrialisation, the village was still a rural idyll, visited by the Parisians in their leisure time. Building land was still cheap and factories, including an iron foundry, which delivered material for the construction of the covered markets in Paris, were erected.

Once Monet and his family had settled in Argenteuil, their life became more peaceful, after the years of need and deprivation. However, in 1874, financial difficulties forced them to move to another location in the village. Monet's former mentor Boudin wrote that he now appeared 'to be quite happy with his lot . . . although he naturally does not want to accept that his painting finds so little recognition.'

The pictures created in Argenteuil give an impression of a happy, harmonious coexistence. He often painted his family in the garden or taking strolls, or his six-year-old son, Jean, at play, proudly presenting the young lad in his Sunday best on his hobby horse in one of the few paintings where Monet was careful in his elaboration of the facial features. In principle, for him, as a landscape artist, 'every leaf on the tree is just as important . . . as the features of a model'. It therefore hardly comes as a surprise that in his *Poppy Field* Camille and Jean are almost submerged in the undulating sea of red flowers, especially where Monet shows the two strollers a second time in the background. The main concern is the wonderful lighting effect of the red poppies in the fresh green of the meadow on this lovely summer's day. Monet was especially fond of these flowers; he painted them repeatedly and planted several varieties in his garden. His friends Caillebotte, Renoir, Manet, and Sisley and their families often visited the hospitable Monet household and the luxuriantly flowering garden. Pissarro, Degas, and Cézanne also dropped by from time to time. Monet created more than 200 paintings in Argenteuil. This period marked the beginning of 'the golden age of Impressionist painting', as it was described by Monet's biographer, Daniel Wildenstein.

Poppies, 1873, oil on canvas, 50 × 65 cm, Paris, Musée d'Orsay

12 EDOUARD MANET
Boating, 1874

Claude Monet and his Wife in the Studio Boat (The Barque), 1874, oil on canvas, 82.7 × 105 cm, Munich, Bayerische Staatsgemälde-sammlungen, Neue Pinakothek

Manet spent a few months of the summer of 1874 in the house of his cousin Jules de Jouy in Gennevilliers. He was already acquainted with the rural area but, as a painter, it had so far held little fascination for the 'heart-and-soul' Parisian. Monet lived nearby in Argenteuil, on the opposite bank of the Seine. Manet often visited the 'Raphael of the water'—as he admiringly called Monet—and under his influence began *plein-air* painting; now water also started to take a magical hold on him. New elements became integrated into his pictures; previously his colour had never shone with such intensity, never before had he captured the ever-changing surface of the water.

However, he remained true to himself: in *Boating*, two people, whose relationship we can only speculate on, form the central point of the picture. They are shown relaxing with the fashionable Parisian leisure-time activity. The man, wearing an elegant boating outfit—Manet's brother-in-law Rodolphe Leenhoff posed for him—is at the helm. He hardly pays any attention to his companion but contemplates his vis-à-vis, the observer, whereas the lady, dressed in chic urban apparel, pays no attention to either. The people in the boat let themselves drift on the water and through their relationship. It is hovering—ambivalent and carefree for one short Sunday.

The times when Manet made new interpretations of old masterpieces, such as *The Lunch on the Grass* (p. 30; inspired by the *Pastoral Concert* which, at the time, was attributed to Giorgione and a detail from Raphael's *Judgement of Paris*) or *The Balcony* (going back to Goya's *Majas on the Balcony*) had passed. The critics were shocked: For them, Manet's earlier reinterpretations had been a sign of his lack of imagination and now they were upset about his connection to the 'Monet gang'. Manet was always good for a surprise and now he had fallen into the 'abyss of Impressionism'—in a second picture painted in the summer, *The Barque*, even more so than in *Boating*. Here, Manet also painted a boat but it was Monet's working place and not a pleasure craft. Inspired by a floating atelier, 'le Botin', which Charles-François Daubigny had constructed in 1857, Monet had had a cabin with just enough room for his canvases erected on a boat. For hours on end, he made painstaking studies of the effects of the water, usually anchored between pleasure craft. His wife, Camille, often accompanied him and he also spent 'unforgettable hours' with Manet on the boat. As a reminder of the time they spent together, Manet painted this studio of Monet's in front of the panorama of the banks at Argenteuil. In this painting, Manet's style comes close to that of his younger colleague: He not only eschewed dark under-painting, applying his paint thickly and directly on the light ground, but he also created the water using short, detached brushstrokes. The colours vibrate: One can almost feel the boat rocking.

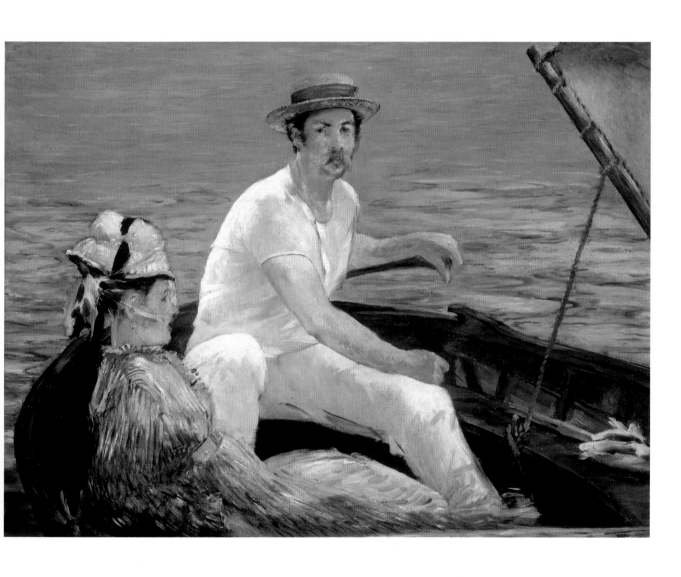

Boating, 1874, oil on canvas, 97.2 × 130.2 cm, New York, The Metropolitan Museum of Art, H. O. Havemeyer Collection, bequest of Mrs H. O. Havemeyer, 1929

13 EDOUARD MANET
The Monet Family in their Garden at Argenteuil, 1874

Auguste Renoir,
Madame Monet and Her Son,
1874, oil on canvas, 50.4 × 68 cm,
Washington, National Gallery of Art

In 1866, Manet became very annoyed at Monet's first major success with his *Woman in a Green Dress* (p. 30), not because of the painting, but because of the critics, who deliberately confused the two artists owing to the similarity of their names. These comparisons were always to his disadvantage. However, his reservations about Monet had long disappeared and the well-off Manet provided his younger colleague with all the support he could, giving him considerable amounts of money, purchasing his paintings and helping in his search for a house. The Monets finally found the right one in Argenteuil.

Manet often visited the passionate gardener Monet there. After he had finally overcome his resistance to *plein-air* painting in 1874, Manet set up his canvas in the garden. Monet recalls: 'One day, fascinated by the colours and light, Manet started to paint a picture in the open air with people [Monet, his wife, Camille, and their seven-year-old son, Jean] under the trees. Renoir came by while the sitting was taking place. He too was enchanted by the atmosphere of the moment. He asked me [Monet] for a palette, brush, and canvas so that he could paint side-by-side with Manet. Manet watched him out of the corner of his eye and, from time to time, went over to get a closer look at the canvas. He then made a face and came cautiously over to me and whispered in my ear: "The young man has no talent! . . . You're his friend, tell him he should stop painting!" . . . Wasn't that amusing of Manet?' Was this one of Monet's inventions, or the truth? If this statement was actually made, we can be sure that it was meant to be an ironic joke: Manet liked Renoir and possessed at least one of his paintings. Incidentally, on the same day, Monet painted the rare sight of Manet in front of his easel in the open air. Today, the painting, formerly in the collection of the German Impressionist Max Liebermann, is considered lost.

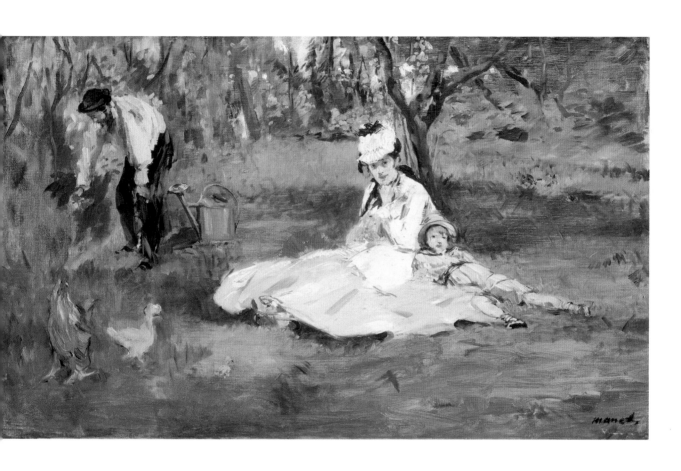

The Monet Family in their Garden at Argenteuil, 1874, oil on canvas, 61 × 99.7 cm,
New York, The Metropolitan Museum of Art, bequest of Joan Whitney Payson, 1975

14

CAMILLE PISSARRO
A Cowherd at Valhermeil,
Auvers-sur-Oise, 1874

'In his case, originality is profoundly human. It is not a matter of dexterity, of a deceitful transformation of nature. It lies in the essence of this painter, in his severity and seriousness. I have never seen pictures of such a masterly depth. In them, one feels the unfathomable voices of the earth; in them, one has a notion of the powerful life of the trees. The severity of the horizon, the disregard for anything spectacular, the absolute absence of any piquancy invests his art with a sense of epic greatness. This reality far transcends the dream. . . . One glance at these works is sufficient to comprehend that a human being is behind them—an uncompromising, honest personality who is incapable of lying and creates a pure eternal truth out of art.'

Pissarro, praised in this way by Emile Zola in 1868, was held in high esteem by his friends. They called the man with the full beard Moses the Apostle. In retrospect, he appeared to Cézanne—for whom Pissarro was a patient mentor, passionate defender and warm-hearted friend, as well as for Gauguin and many others—'a father . . . a man, whom one asked for advice and who was something like the good Lord'.

Pissarro had little interest in bourgeois amusements or hectic urban pastimes and spent most of his life in the country. Having left Pontoise, to the north-west of Paris, in 1869 on account of the approaching Prussian troops, the artist moved back to the village in 1872. The area was rural, too far from Paris to be visited at weekends by day-trippers. It was exactly the right place for Pissarro, who sought out his motives in the everyday, unspectacular rural life of the seasons, tirelessly wandering through the area and often setting up his easel, as in this case, on a path leading into the distance. The construction is clear; the restrained coloration, with numerous shades of green, blue and yellow, applied with relatively short brushstrokes, imparts a feeling of tranquillity and peace—the simple, natural coexistence of man and the rest of creation.

This picture was painted in the year of the first Impressionist exhibition, for which Pissarro had drawn up the statutes during the previous summer. Pissarro was the only one to take part in all eight Impressionist exhibitions, always hoping for success, but he had to wait longer than most of his friends. The father of eight was often forced to live at subsistence level. However, in spite of his plight, he did not allow himself to become disheartened and even encouraged his son Lucien to take up a career as a painter in 1883: 'The painter must have nothing more than an ideal before his eyes. He vegetates, that is certain, but in his misery he finds a hope which will stand by him, and that is to find somebody who understands him. It usually happens.'

A Cowherd at Valhermeil, Auvers-sur-Oise, 1874, oil on canvas, 54.9 × 92.1 cm, New York, The Metropolitan Museum of Art, gift of Edna H. Sachs, 1956

15

AUGUSTE RENOIR
La Loge (Theatre Box), 1874

Auguste Renoir wrote: 'For me, the action also takes place in the auditorium. The audience is just as important as the actors!' At that time, theatres were still brightly illuminated during performances: it was not until later that lights were extinguished when the curtain was raised, forcing the audience to focus its attention on the stage. So there was nothing to stop Renoir's gaze from wandering around the auditorium; in 1874 the audience was still a decorative, albeit silent actor. To see and be seen—the latter applying particularly to the ladies, who appeared in enchanting gowns, bejewelled with precious gems. The seats in the boxes could be moved, allowing the ladies to show themselves from the balustrade. This was to the advantage of their well-to-do escorts: Husbands or lovers, they were responsible for the wardrobe of their companions, decorating themselves with their decorated women. Naturally, only the financially solvent could possibly devote themselves to such pleasures: apart from the investment in the outward show, an opera ticket cost as much as an unskilled labourer received at the end of the month. The cost of the evening was an investment in one's own prestige.

Charming beauties, such as Nini Lopez, one of Renoir's new models at the time, appeared particularly attractive in their flimsy garments. In this painting, she is seductively enveloped in the *geule de raie* (fish mouth), a modern dress of white silk trimmed with black fur. No jewellery could be more beautiful than the palely shimmering pearls and the fresh flowers with their hint of pink. The rustling material of her dress is voluminous but the colours are simple: they do not steal the show from their wearer but emphasise Nini's porcelain complexion. Her self-assured and tranquil glance is neither challenging nor suggestive. As in a picture within a picture, this woman is framed by the box and her companion (Renoir's younger brother modelled for him here). In the evening, the gentleman becomes secondary, a marginal figure, to the magnificence of the woman. In the dimly lit box, he looks around the auditorium through his opera glasses: Is anyone more beautiful than the woman next to me?

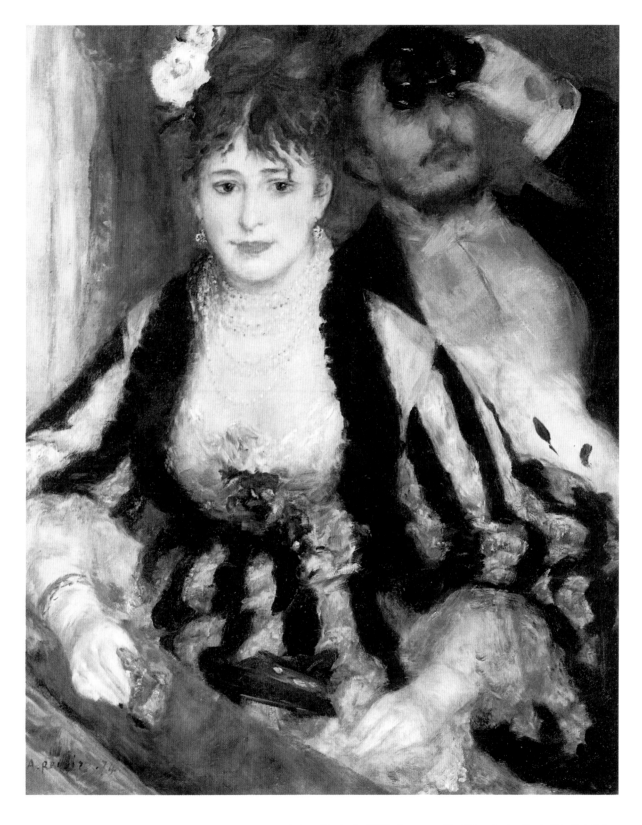

La Loge (Theatre Box), 1874, oil on canvas, 80 × 63.5 cm, London, Courtauld Institute Gallery

BERTHE MORISOT
Woman at her Toilette, 1875–80

Edouard Manet,
Berthe Morisot with a Bouquet of Violets,
1872, oil on canvas, 55.5 × 40.5 cm
Paris, Musée d'Orsay

The sisters Berthe and Edma Morisot were enthusiastic painters. They took private lessons from various artists and copied the masterworks in the Louvre for their studies. One day in 1868, one of their wishes was fulfilled: In the museum, they were introduced by the artist Henri Fantin-Latour to the 'scandalous painter' Edouard Manet. The sisters adored him. Manet wrote to Fantin-Latour that the 'young Morisot ladies are charming. It is a pity that they are not men. But even as women they can be of service to painting, by each marrying an academic painter and sowing contention between the two old fogies. However, that would require a certain amount of willingness to make sacrifices.'

Manet's opinion was to change and he soon learned to admire Berthe Morisot not only as a friend and good conversational partner, but also as a painter whose opinion he greatly respected until his death.

Of course, Morisot's paintings, which usually showed women in their bourgeois homes, were not as scandalous as Manet's. Here, an unidentified woman is preparing herself for her appearance in public; she is alone. She is not posing, not playing with the effect she has on a (male) observer, as is the case in Manet's *Nana* (p. 68). None of Morisot's colleagues had such an unprejudiced, indifferent view of the intimate moments in the everyday life of a woman, moments which she depicted with a great deal of affection. The woman, captured in light, delicate colours, appears to be fresh, airy and gentle. Wonderfully swirling brushstrokes make the dress almost melt into the background. The critic Charles Ephrussi enthused: '[Morisot] spreads petals on her palette so that she can distribute them over the canvas with gentle, unerring—only apparently random—brushstrokes.'

For a period, Berthe was Manet's favourite model. She posed for fifteen paintings and he always portrayed her dressed in simple black or white. It was as if Manet, who was generally very interested in the toilette of women, did not want to distract from her face and to capture the very essence of her being. His favourite picture was the one where he painted her with a bouquet of violets. When it was auctioned in 1894, Berthe Morisot bought the portrait as a souvenir of her dear friend, whose brother (as she confided in her sister) she had married for reasons of convenience.

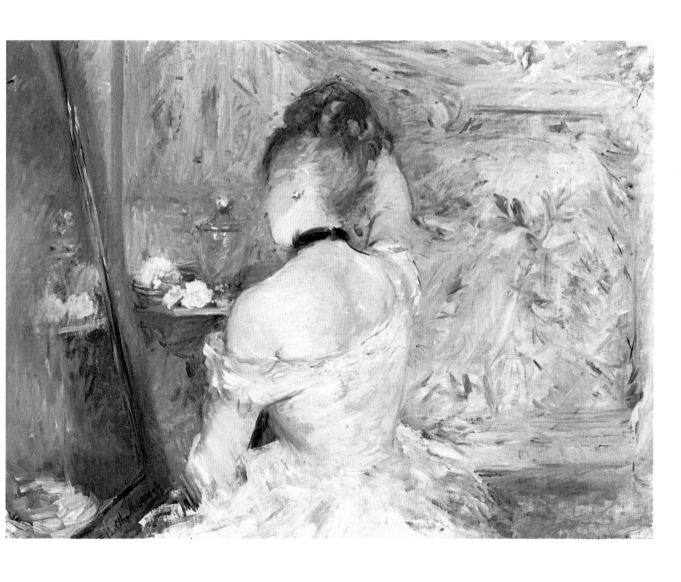

Woman at her Toilette, 1875–80, oil on canvas, 60.3 × 80.4 cm, Chicago, The Art Institute of Chicago, Stickney Fund, 1924

17 EDGAR DEGAS
Absinth (or: In the Café), 1875/76

Edouard Manet,
Plum Brandy, c. 1877,
oil on canvas, 73.6 × 50.2 cm
Washington, National Gallery of Art,
Collection of Mr and
Mrs Paul Mellon

Ellen Andrée, a star of the Folies-Bergère entertainment palace, was always dressed with astonishing elegance. However, as an actress, she was able to slip into different roles; in this painting, she poses for her friend Degas as a simple woman, alongside the painter and copperplate engraver Marcellin Desboutin.

As if passing by the café, one catches a brief glimpse over matches and a newspaper lying on a table, of a couple stranded in a café. The disillusioned woman slouches with an absent gaze in front of a glass of absinth. At the time, this alcoholic drink was particularly popular with working-class men and women, though its effect was devastating: The 'green fairy' led to chronic poisoning, permanent damage to the nervous system and bodily ruin. This is clearly not the first glass the woman has drunk: slumped over, her legs half stretched out, she stares apathetically into the void. Her companion, with bloodshot eyes, is trying to recover from the alcohol with Mazagran, a widespread hangover remedy. Relaxed but attentive, he follows the life of the city unfolding around him. 'Making portraits of people in typical, familiar poses and paying particular attention to making their faces as expressive as their bodies'— Degas' most famous café painting fulfils this maxim.

The Café La Nouvelle-Athènes on Place Pigalle in Montmartre is shown in this painting. In the period of Napoleon III it had a bad reputation as it was a meeting place for political dissidents such as the painter Gustave Courbet and the republican Léon Gambetta, who proclaimed the Third Republic in 1870. After 1875, Renoir, Pissarro, Monet and Cézanne were occasional guests but the café was more frequently visited by Gustave Caillebotte, Degas and Edouard Manet who, as well as Degas, often made sketches of the motley group of clients. It was in this café that Manet placed the woman in front of the plum brandy (left). She is clearly not of the bourgeoisie—it was forbidden for bourgeois women to visit such establishments unaccompanied, not to mention to consume alcohol and tobacco alone. In an extreme close-up, Manet concentrates entirely on the individual. Here, one does not get a glimpse in passing by: The viewer is forced to concentrate on the woman sitting alone, amidst the activity of the big city. As so often in Manet's work, her expression is puzzling. Is she dreaming, waiting for someone, disappointed?

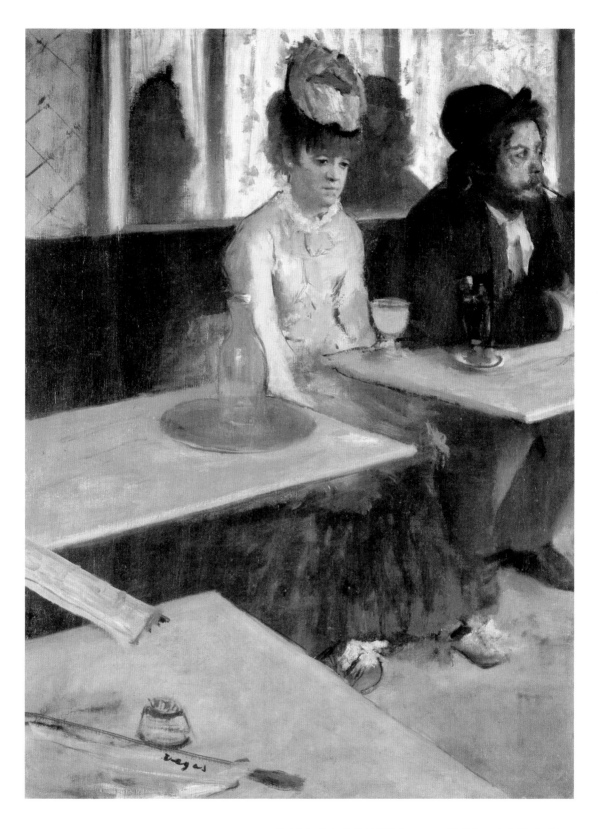

Absinth (or: In the Café), 1875/76, oil on canvas, 92 × 68.5 cm, Paris, Musée d'Orsay

18 **AUGUSTE RENOIR**
Nude in the Sun, c. 1876

LE PEINTRE IMPRESSIONNISTE.
— Madame, pour votre portrait il manque
quelques tons sur votre figure. Ne pourriez-
vous avant passer quelques jours au fond d'une
rivière?

Caricature (The Impressionist) 1877:
We are still missing a few colours
for your portrait. Couldn't you spend
a few days on a riverbed?'

A pretty, blossoming young girl, 'dressed' only with a bracelet and ring, sits dreaming in the green. The light, falling through foliage rustled by the wind, dances over her body. Renoir attempts to capture this flickering; it almost appears that this is his main concern. However, he esteems the beguiling charms of women too much, knows how to flatter them. The actress Jeanne Samary, with whom he had a relationship some years after this painting was created, stated: 'He captures all women—with his brush.' She must have known: She had herself been portrayed by him no fewer than thirteen times.

One of his earlier lovers, Marguerite Legrand, known as Margot, posed for this picture in the overgrown garden of his atelier on Rue Cortot in Montmartre, where the *Dance at the Moulin de la Galette* (p. 66) was also created. Two years later, in 1878, she caught typhoid. Renoir took care of her but she died in spite of medical treatment.

In 1876, Renoir exhibited this charming picture, also known as *Torso of Anne*, as a study. It was torn to shreds by the contemporary critics. As always, Albert Wolff, the conservative critic of *Le Figaro* was particularly scathing. He was opposed to all new artistic developments and felt himself to be the guardian of beauty in literature, even making enraged, sweeping attacks against the novels of Emile Zola. In his judgement of art he also felt that it was his duty to protect his readers from messy splatters of paint. He considered what he saw—or wanted to see—in this painting to be scandalous, 'a piece of rotting flesh with green and violet blotches typical of a corpse in the final stages of decomposition'.

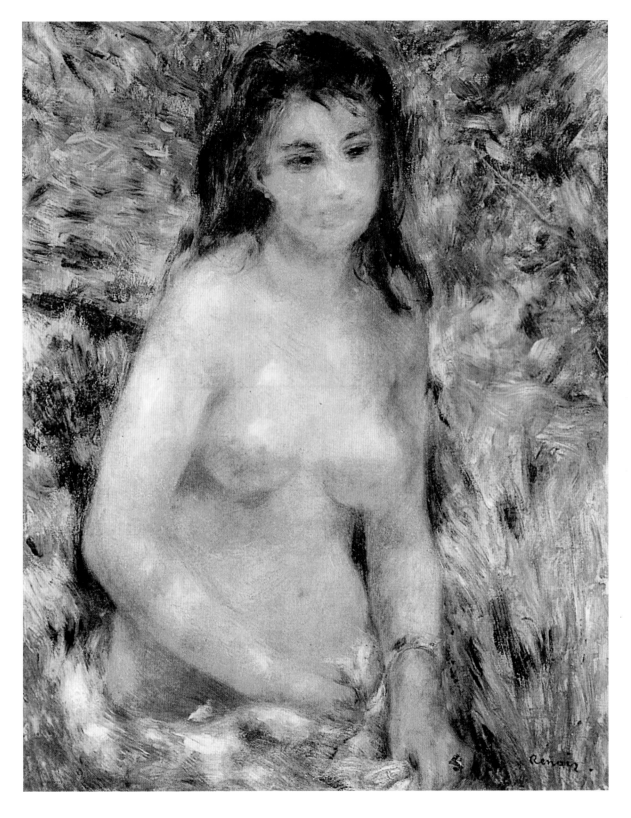

Nude in the Sun, c. 1876, oil on canvas, 81 × 65 cm, Paris, Musée d'Orsay

19 AUGUSTE RENOIR
Dance at the Moulin de la Galette, 1876

Montmartre had changed a great deal since 1860. The village had been incorporated into Paris and, gradually, the rural area was losing its charm. As a result of the low rents, the quiet streets had become populated by the less well heeled: farmers and labourers, seamstresses and milliners, students and artists. The fourteen mills on the hill had less and less to grind. This was also the case with the Moulin de la Galette. The owner, Debray, discovered a new area of business: little by little, he turned the mill into an inexpensive tourist inn. His wonderful galettes (savoury crêpes) were extremely popular; on sunny Sundays, the warm air was full of music, laughter and the babble of voices. Forgetting the poverty and misery a short distance away, the young people of Montmartre flocked to dance under the acacia trees. Here, not only modest quadrilles were danced, where the most one could do was touch hands: the Viennese waltz allowed for real bodily contact. A ten-man band played from three in the afternoon to eleven at night; after darkness fell, the gas lamps were lit.

Renoir, who for the last year had had his studio in a dilapidated building nearby, frequently wandered over to the 'Moulin'. He loved the cheerful, carefree, exuberant atmosphere—so much that he decided to preserve it in a painting. 'Renoir found models who, in his eyes, had the advantage that they did not normally model in other artists' studios.' His friends and their companions—flower sellers, dressmakers, and milliners—lived on Montmartre Hill, often in miserable conditions. However, on a day like this, wearing their Sunday best, all was forgotten.

Dressed in the latest fashion, Jeanne Margot bends over her sister Estelle, both seamstresses without permanent employment. Renoir was particularly attracted to Jeanne, who wears a hairnet adorned with pearls. 'The girl was charming, wonderful hands, the tips of her fingers a bit swollen from the pin pricks.' With her large black eyes and light-coloured hair, the sixteen-year-old matched his ideal of a woman. Some of Renoir's friends are seated at the table with the girls: the painters Pierre Franc-Lamy, with the rays of sun flickering through the foliage onto his back, the pipe-smoking Norbert Goenuette, and Georges Rivière, wearing a straw hat. One year after the creation of this painting, he will defend the new artistic style in his magazine *L'Impressionniste*.

The artist worked for almost half a year on this painting. He made careful studies of the poses and the individual people and prepared numerous sketches at the location. In his studio, he transformed them into a homage to the simple forms of Sunday dancing pleasure, to harmony and exuberance. According to Rivière, the picture 'is a part of history, a precious monument to Parisian life, painted with tremendous accuracy. Nobody before [Renoir] had ever thought of transferring a scene of everyday life to a canvas of this size.'

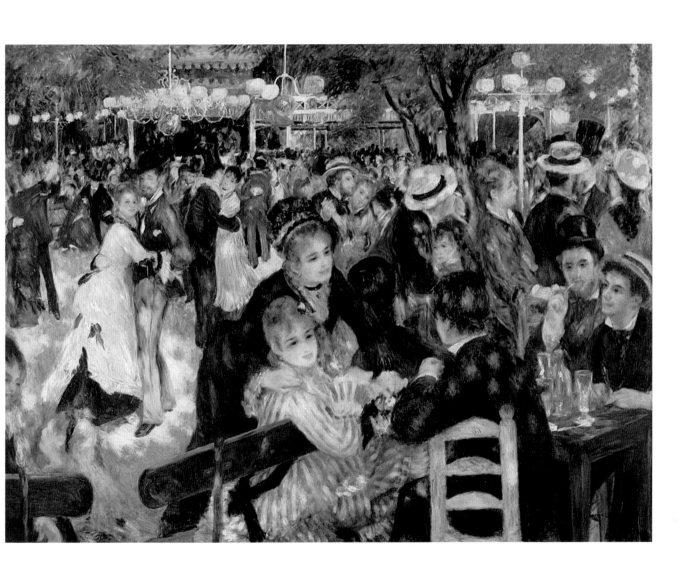

Dance at the Moulin de la Galette, 1876, oil on canvas, 131.5 × 176.5 cm, Paris, Musée d'Orsay

20

EDOUARD MANET
Nana, 1877

A scandal: *Nana*, exhibited in the window of a bric-a-brac shop on the Boulevard des Capucines! There were demands for the police to remove it, from 'decent citizens', appalled that such an immoral painting with a member of the 'oldest profession' gazing impudently at the viewer could be shown in public, where a voyeur could clandestinely catch a glimpse when he thought no one was looking. Did this outrage make an impact on its model Henriette Hauser, a soubrette and lover of the Prince of Orange who was known all over town?

The same happened when Zola's *L'Assommoir*, part of his Rougon-Macquart cycle, was also 'scandalised'—and turned into a bestseller. The novel tells the story of the childhood and youth of a precocious little madam, Nana, whose upper-class lovers doll her up in elegant clothes. Manet was deeply impressed by the novel and this clearly influenced his decision when he was giving his painting its title. Zola described the novel in the following way: 'The whole of society is on her tail. A pack is hot on the heels of a bitch, who is not in heat and makes fun of the dogs following her. The poem of male desire, the great lever which can set the world in motion.' Nana holds her power and that of those after her firmly in her hands (even though the moralist Zola could not resist punishing her with a miserable end).

Manet's Nana is also aware of how she exerts her charms. She is the one who determines the action of the drama. In her search for new, lucrative prey, she takes aim at the viewer—also the viewer of the painting—while the purchaser sits and waits. In this cash-for-flesh arrangement the man is not forced to be polite, he does not even take off his top hat, which was fashionable with playboys of the day in such situations. That would be showing too much respect for such a woman, even if she was one of the aristocrats of her profession. This is clear from her underwear and stockings, which Huysmans, the lingerie specialist and friend of both Manet and Zola, discloses in a review of the picture, including the place where the stockings were produced. Despite the fine fabric, the man in the painting gazes emptily into space, holding his cane firmly in his hands. Maybe the relationship to this seductive woman is too incredible, overwhelming him and his fantasy and becoming uncontrollable: 'His entire being rebels; the slow possession-taking, the way in which Nana has recently taken hold of him, terrifies him and reminds him of his pious readings about being obsessed by the devil. . . . Nana, with her smile, with her breast and derrière, both swollen with vice, was, in a way, the devil.' It almost appears as if the picture had inspired Zola. Whenever he visited Manet in his studio, he saw the painting. It remained there until the death of the painter before being auctioned for 333 francs as part of his estate. Ten years later, it changed owners for 9,000 francs and was offered for sale in 1910 at the price of 200,000 francs. . .

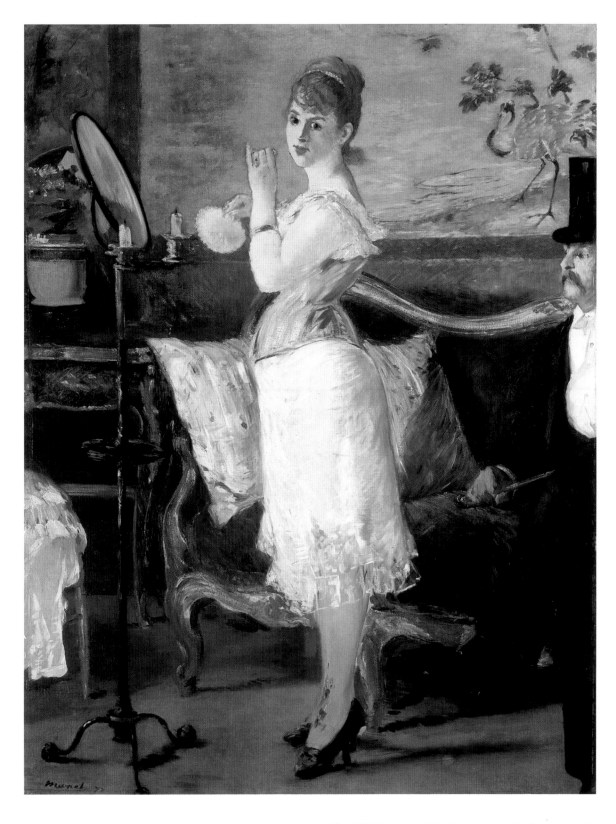

Nana, 1877, oil on canvas, 154 × 115 cm, Hamburg, Hamburger Kunsthalle

21 GUSTAVE CAILLEBOTTE

Paris Street, Rainy Day, 1877

Baron Georges-Eugène Haussmann was Prefect of Paris between 1853 and 1870 and, commissioned by Napoleon III, radically reshaped the city. As if using a machete, he slashed through the city jungle which, in many sections, still had a medieval appearance, razing entire quarters. Forty thousand new houses—public buildings, private palaces and apartment complexes—were erected along approximately fifty kilometres of the new boulevards. The reconstruction was expensive, requiring 2.5 billion francs, fifty times more than the budget.

Caillebotte was fascinated by these new urban developments. It was not only in this painting, which was the main attraction of the Third Impressionist Exhibition in 1877, that he depicted the modernised Paris. The daringly composed picture shows the junction of the Rue de Moscou and Rue de Turin, not far from the Saint-Lazare Station (p. 72). To the left, the view is drawn through the monumental canyon of houses into the distance whereas the right section of the painting shows an extreme close-up of anonymous passers-by, dressed in an elegantly restrained fashion. The face of the woman is covered by a delicate veil, her ear is adorned with a dimly glowing pearl. What she and her companion are looking at remains a secret, as does whether the distracted lady will murmur a pardon when their umbrella collides with that of the gentleman coming towards her. He is not shown completely, which makes the section of the picture appear coincidental, like a snapshot.

The carefully covered surface of the painting, where we do not see the short brushstrokes typical of the Impressionist style, and its ambitious format stand in contrast to Impressionism; the motif of life in a city, on the other hand, does not. A critic wrote: 'Caillebotte is an Impressionist in name only. He really knows how to draw and paints more seriously than his friends.'

Caillebotte was introduced into the circle of the Impressionists by Degas. He came from a well-to-do textile-making family and often helped his less-affluent friends by purchasing their works, ultimately owning the most important art collection of Impressionist paintings of the day with sixty-seven pictures. Caillebotte died, aged only forty-six, in 1894. However, he had already made his testament, with Renoir as the executor. By donating his collection to the French state, Caillebotte intended to open the doors of the holy halls of the Louvre to the Impressionists: That was his ulterior motive. Renoir therefore organised a meeting with an important official of the Académie des Beaux-Arts, who was embarrassed: 'Why on earth did your friend send us this Trojan Horse?' The resistance to accepting the donation was particularly strong among the salon painters and professors of the Académie. Renoir fought for two years to fulfil Caillebotte's last will, though ultimately more than half of the paintings were refused. Many years later, in 1928, the French state had a different opinion and attempted to acquire the remaining pictures from Caillebotte's heirs.

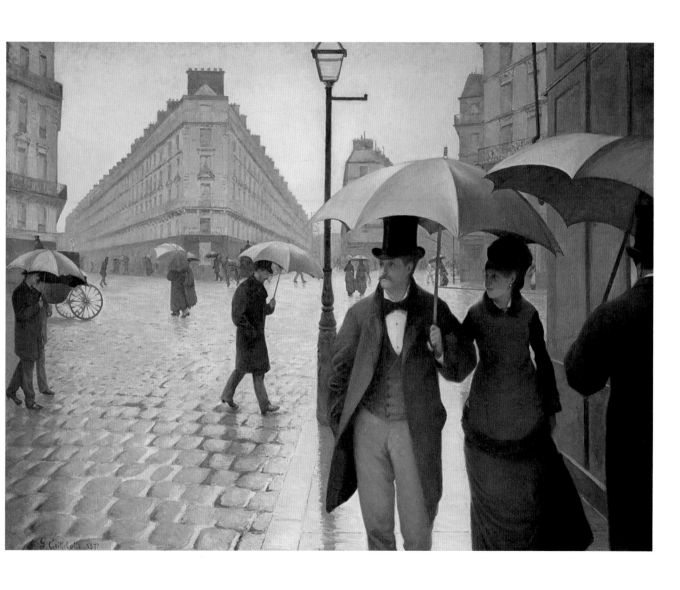

Paris Street, Rainy Day, 1877, oil on canvas, 212.2 × 276.2 cm, Chicago, The Art Institute of Chicago, Charles H. and Mary F. S. Worcester Collection

CLAUDE MONET
Saint-Lazare Station, 1877

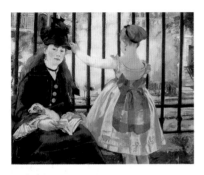

Edouard Manet,
The Railway, 1873, oil on canvas,
93.3 × 111.5 cm, Washington,
National Gallery of Art, gift of
Horace Havemeyer in memory
of his mother, Louisine W. Havemeyer

Along with Caillebotte's *Paris Street, Rainy Day* (p. 70) and Renoir's *Dance at the Moulin de la Galette* (p. 66), Monet's seven paintings of Saint-Lazare Station were the greatest sensation of the Third Impressionist Exhibition of 1877. The building of the most important Parisian station of the period—with more than twenty-five million passengers per year—is a technical masterpiece, constructed of iron and glass. Contemporaries were impressed by the impact made by the light, and the poet Théophile Gautier declared railway stations to be the 'new cathedrals of humanity'.

Monet's landscape *Impression, Sunrise* (p. 48) had been generally torn to shreds because he had painted fog and mist and no clearly defined objects could be discerned. Years later, he still felt goaded by this lack of understanding. Renoir recalls that, one morning, he was awakened by his friend, 'shouting: "I've got it—Saint-Lazare! When the trains pull out, the clouds of smoke are so thick that you can hardly make anything out. It's magical, just like a fairytale come to life." Naturally, he wanted to paint the station in front of the object and, obsessed as he was, he proclaimed: "The train to Rouen should be delayed. The light is much better thirty minutes after its scheduled departure." . . . [Monet] put on his best clothes, adjusted his cuffs to perfection and, casually swinging his cane with the golden knob, presented his visiting card to the director of the west railroad line at the Saint-Lazare Station. The porter stiffened and ushered him in without delay. The high-level official asked his visitor, who had introduced himself with the utmost simplicity saying, "I am Claude Monet, the painter," to be seated. The director had no idea about painting but was afraid to admit it. Monet kept him on tenterhooks before deigning to tell him the important news. "I have decided to paint your train station. I fluctuated between the Gare du Nord (North Station) and yours for a long time, but now I have the feeling that yours has more character." Monet got everything he wanted: Trains were delayed, platforms closed and the locomotives filled with coal so that they could puff out as much smoke as Monet desired.' Through the steam coming out of the funnels and points of the tracks one can barely make out the Pont de l'Europe and the houses opposite in the background of Monet's painting. Smoke captured beneath the glass windows, a dazzlingly blue sky, light and shadow—an infinitely changing interplay, frozen into a painting.

Manet's painting with the same title (left), which was created four years previously and exhibited in the 1874 Salon, is much more tranquil. However, is this transport junction really the object of his observations or do people play the central role, as in so many of his paintings?

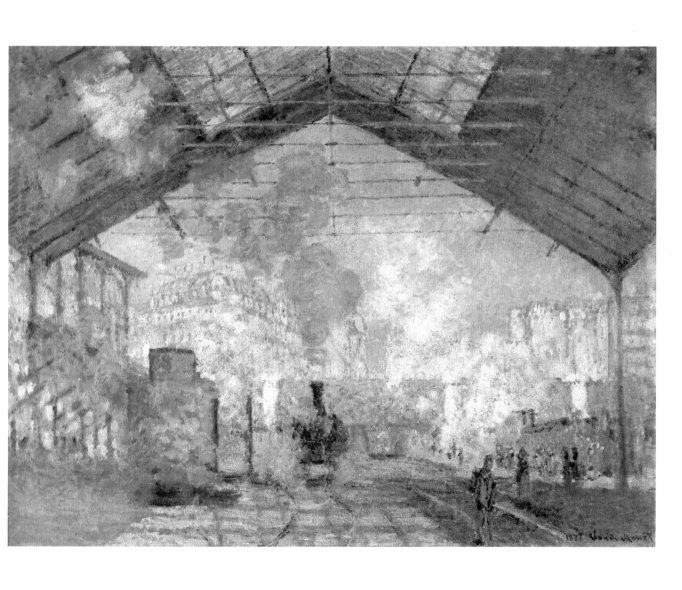

Saint-Lazare Station, 1877, oil on canvas, 75 × 105 cm, Paris, Musée d'Orsay

23 AUGUSTE RENOIR

Madame Georges Charpentier and her Children, Georgette-Berthe and Paul-Emile-Charles, 1878

The publisher Georges Charpentier was not only a friend and supporter of the Naturalists but had also entrusted the controversial Zola with the literary leadership of his publishing house. Charpentier and his wife, who had Republican tendencies, were among the early collectors of Impressionist art and founded a gallery. The first solo exhibition was devoted to their favourite painter, Renoir, followed in 1880 by Monet and Manet and in 1881 by Sisley.

Charpentier, a friend of Manet's, had become acquainted with Renoir only a few years before the gallery opened. He not only purchased a picture from him but also asked Renoir to portray his wife and children. This was a stroke of luck, not merely because the family was influential in Parisian cultural and social circles. Renoir enjoyed painting them, too: 'Madame Charpentier reminds me of the loves of my youth—Fragonard's models.' He was delighted by the children's 'charming dimples' and because they were 'models who pose free of charge and full of goodwill'. Emile Zola's three-year-old godson, Paul-Emile-Charles , is seated next to his mother, dressed and coiffed like his sister Georgette-Berthe, who is three years older and has made herself comfortable on the St Bernard dog. Her dress, and the walls with their decoration influenced by Japanese art, create a feeling of restrained elegance.

When Charpentier commissioned the painting, he insisted that Renoir also come to the jours fixes which his wife held every Friday. Renoir did not usually feel very much at ease in upper-class salons but actually enjoyed those at the Charpentiers' very much. Once, however, he almost missed an invitation because he was painting in Marly. It was the evening when he was supposed to meet the famous-infamous Léon Gambetta—opponent of the Empire and proclaimer of the Third Republic, and Renoir missed the train to Paris. He quickly jumped onto a goods train, raced home, changed his clothes without putting on a new shirt but simply a new collar and false front. When he finally arrived, he gave the servant his top hat, scarf and gloves, but forgot to put his jacket back on before entering the salon, where he was 'greeted with uproarious laughter. Amused, Charpentier also took off his jacket and all the other men followed suit. Gambetta declared that this was the "democratic" way of doing things. The dinner proceeded with its usual merriment.'

The Charpentier family's influence made it possible for the commissioned portrait Madame *Georges Charpentier and her Children* to be exhibited at the 1879 Salon, where it was an enormous success. This was followed by additional commissions for portraits; the artist's precarious financial situation was a thing of the past.

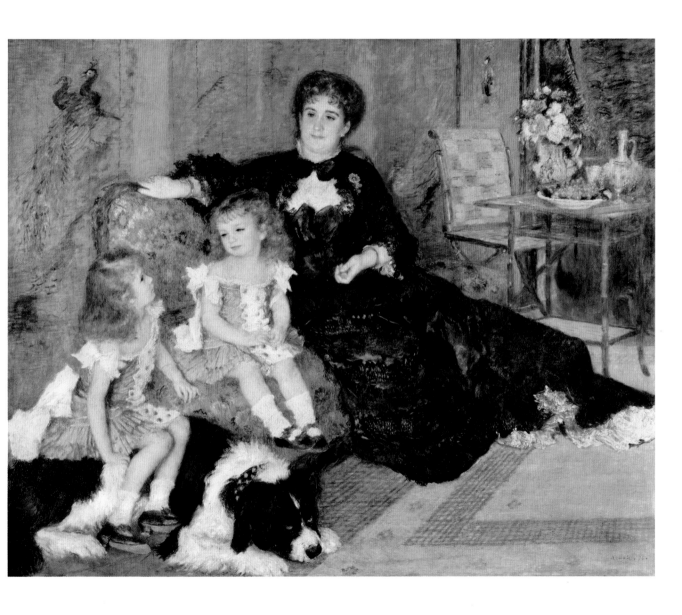

Madame Georges Charpentier and her Children, Georgette-Berthe and Paul-Emile-Charles, 1878, oil on canvas, 153.7 × 190.2 cm, New York, The Metropolitan Museum of Art, Catharine Lorillard Wolfe Collection, Wolfe Fund, 1907

24 CLAUDE MONET
Rue Saint-Denis,
Celebration of 30th June 1878, c. 1878

Edouard Manet,
Rue Mosnier with Flags, 1878,
oil on canvas, 65.4 × 80 cm,
Los Angeles, The J. Paul Getty Museum

The atmosphere during the third Paris World's Fair in summer 1878 was euphoric. France seemed finally to have recovered from the horrors of the Franco-Prussian War and the Paris Commune. Numerous events reflected the happiness and joy over the rebirth of the nation on that 30 June, the first national holiday of the Third Republic. That the date was chosen quite arbitrarily hardly bothered anybody: The monarchist majority in the parliament was strictly against the—all too obvious—14 July (the day when the Parisian population had stormed the Bastille in 1789 and ignited the French Revolution).

On that day, huge crowds of people, both French and visitors from abroad, wandered through the quarter where the Parisian market halls were located. Small streets, such as Rue Saint-Denis and Rue Montorgeuil, led to the cast-iron and glass masterpiece which covered nine hectares and had been erected by Victor Ballard and Felix Emmanuel Callet between 1851 and 1859. One of those there was Monet. Who knows if he had chosen precisely this quarter because *Le Figaro* had expressly recommended it to its readers. It was the centre of the cloth trade and it could be expected that its inhabitants would follow the call to decorate their houses with flags enthusiastically and effortlessly. In 1920, Monet recalled that 'I liked the flags. When the national holiday was celebrated for the first time on 30 June, I went strolling on Rue Montorgeuil with my equipment; the street was overflowing with flags and full of people. I then sought out a balcony . . . and asked for permission to paint from it. This was granted. I then went down, once again, incognito.' On this one day, Monet painted almost identical pictures there and on Rue Saint-Denis.

However, Paris did not show itself everywhere from its most attractive side. The atmosphere of Manet's picture (left), which was painted on the same day near Saint-Lazare Station, is completely different. He looked out of his studio window onto the almost deserted Rue Mosnier. The flags which hang out of the windows appear subdued. Here, even though there is dazzling sunshine, the light appears cheerless, too bright and clear and it glares down on the war veteran, dragging himself laboriously along the street. The contrast between him and the demands placed on the day are obvious. Where Monet's picture and the cheerful throng shown in it obliterates the recent history of the country, Manet brings it radically back to mind in the figure of this man, whom he shows so graphically, recalling the great losses at the beginning of the 1870s during the Franco-Prussian War and the Commune.

Rue Saint-Denis, Celebration of 30th June 1878, c. 1878, oil on canvas, 76 × 52 cm, Rouen, Musée des Beaux-Arts

EDOUARD MANET
In the Conservatory, 1878/79

Manet was forced to leave his atelier in 1878. His neighbours had complained because he had been so bold as to hold a private exhibition there of two paintings which the Salon had turned down. He rented the recently vacated studio of one of his colleagues, which was decorated in keeping with the dernier cri: a hothouse full of exotic plants. Friends of Manet's posed for him there for five months in 1878/79: Jules Guillemet, the owner of one of the most prestigious Parisian fashion stores, and his American wife, who was famous for her elegance and beauty. The painter, who had been fascinated by exquisite clothing since his youth, corresponded with the fascinating woman on matters of fashion.

Manet paid scrupulous attention to Madame's toilette. The seat of the sofa is even tilted a little so that her magnificent afternoon dress is shown to complete advantage; the pleats of the skirt reflect the luxuriant flora surrounding her. The light yellow of her umbrella, hat and gloves harmonises perfectly with the grey. Flowers play around her head, contrasting with her distanced, elegant expression. Madame Guillemet sits there controlling the room, relaxed and self-assured. Engrossed in herself, she hardly seems to notice her husband. Even though he is bent over her, Monsieur Guillemet's gaze wanders into space: Their relationship appears to be ambiguous, as unnatural as the plants surrounding them. Manet knew how to make use of glances—of unmistakeable affection (as in *The Lunch on the Grass*, p. 30) or aversion—to generate an entire, enigmatic universe of questions. In this hothouse, only the ringed hands of the couple approach each other cautiously, captured by Manet shortly before they touch. However, this impression of closeness is immediately thwarted: Could it be that his hand is only in that position because of the cigar between his fingers?

The director of the Berlin National Gallery, Hugo von Tschudi, closed his book on Manet, which was published in 1902, with a play on words: 'Manet—et manebit' (Latin for: he remains—and he will remain). A debate in the Landtag which took place two years later shows that not everyone in the Prussian capital was convinced of this. It was in connection with precisely this painting, with its suggestive eroticism, even immorality. The Empress, nobility, bourgeoisie—all were irritated by the painting, even antagonised by it—and annoyed at Tschudi as well. Accompanied and advised by Max Liebermann, he had chosen to purchase this painting, which had been exhibited in the 1879 Salon: the first museum director to have the courage to acquire a Manet for a museum.

In the Conservatory, 1878/79, oil on canvas, 115 × 150 cm, Berlin, Staatliche Museen zu Berlin, Neue Nationalgalerie

26 BERTHE MORISOT
Young Woman Seated on a Sofa, c. 1879

Renoir reminisced: 'My friendship with Madame Morisot was one of the most valuable I ever came across. She was a painter who was suffused with the grace and subtlety of the eighteenth century . . . one of the last artists with elegance and feminine gentleness we have had since Fragonard.' The Morisot family was indeed distantly related to the Rococo painter and it is possible that the artistic leanings of Berthe Morisot and her siblings Edma and Yves can be traced back to this. In any case, they had the good fortune to be encouraged by their parents, though only Berthe made painting her profession. Her teacher Guichard warned her mother: 'Are you aware of what this means? In the upper middle-class circles you belong to, it is something of a revolution—I could almost say a catastrophe!' However, and this is most unusual, the family did not try to stop her.

Berthe and Edma studied with Guichard because women were not admitted to the Ecole des Beaux-Arts. The general opinion of the time was that 'real' art was only a profession for men because it demanded reason and intellect, attributes which women 'quite simply did not have'; they were more emotional creatures. Women were, however, permitted to copy 'witlessly' in the Louvre and it was there that Edma and Berthe became acquainted with Camille Corot. At the sisters' insistence, Corot gave them two years of instruction in *plein-air* painting. They rode with him on mules and horses through the Pyrenees on their hunt for motifs; for bourgeois girls, this was something quite exceptional.

The girls were completely at ease in their dealings with the artistic avantgarde. Their mother held receptions on Thursday evenings where the guests included Emile Zola, the painters Puvis de Chavannes, Henri Fantin-Latour, Claude Monet and Edgar Degas. The two last mentioned and Edouard Manet became Berthe's best friends. Their influence, and perhaps that of her distant relative Fragonard, were to lead her to her own style: a gently, flowing way of painting with which she portrayed bourgeois ladies and children in interiors and gardens, subjects which stemmed from her everyday life. However, she did not merely paint her family and friends: As is the case with this painting, she also hired models. Her background and her marriage with Eugène Manet, Edouard's brother, who had no need to work and lived off the family's fortune, made it possible for her to devote herself to painting, free of the necessity of her work being financially successful.

Young Woman Seated on a Sofa, c. 1879, oil on canvas, 80.6 × 99.7 cm, New York, The Metropolitan Museum of Art, partial and promised gift of Mr and Mrs Douglas Dillon, 1992

MARY CASSATT
The Cup of Tea, 1880/81

Edgar Degas,
Mary Cassatt at the Louvre:
The Paintings Gallery, 1885,
etching and pastel, 30.5 × 12.6 cm
Chicago, The Art Institute of Chicago,
bequest of Kate L. Brewster, 1949

Lydia Simpson Cassatt, the artist's sister, was the model for the painting which 'effortlessly combines a delicate, reserved atmosphere with the omnipresent perfume of Parisian elegance. This appears to be an intrinsic component of the talent with which Miss Cassatt—who, I believe, is American—has created a new image of the French woman. However, she transports the benevolent feeling of "being at home" into this typical French living environment. Here in Paris, she has created that which none of our French artists knows how to express: the peaceful contentment of an interior,' was the opinion of the author and critic Joris-Karl Huysmans after seeing the painting in the Sixth Impressionist Exhibition.

Cassatt was forced to take on these subjects which 'she knows how to express' as no other painter—the easy-going atmosphere of homes and gardens—if she wanted to portray people. Public rooms were off limits to her: It was not fitting for a bourgeois woman to leave the house without accompaniment. Cafés, where her male colleagues could talk until they were blue in the face, were also taboo. Courage and a strong will were necessary if a woman wanted to become seriously involved in painting. Cassatt's father, a Pittsburgh banker, was less than pleased about his daughter's intention of becoming an artist. He is reported to have said that he would rather she were dead! However, she got her way and took lessons in Paris in classes open exclusively to ladies, led by the fashionable painter Charles Chaplin; she copied in the Louvre and was successful at the Salon with her paintings in the style of the old masters. Then, one day, she saw Monsieur Degas at the art dealer Pastelle's. She later said that the encounter 'changed my whole life'. Degas had been impressed by her work in the 1874 Salon and recognised a spiritual affinity: 'Here is somebody who thinks exactly as I do.' After they became acquainted in 1877, he asked her to exhibit works in the Fourth Impressionist Exhibition, to which Cassatt 'enthusiastically agreed. At last, I could work completely independently without taking the jury into consideration! I had known who my models were for a long time. I admired Manet, Courbet and Degas.'

Enthralled by her new friends, she undertook everything possible to make their art known to her countrymen. She persuaded the art dealer Durand-Ruel to organise exhibitions in the USA in order to attract new clients. Her friend, Louisene Waldron Elder, and the man who was later her husband, the industrialist Henry O. Havemeyer, were the first important American collectors of Impressionism; on Cassatt's recommendation, they initially bought works by Degas and, later, by the other Impressionists. In 1912, Louisene paid half a million dollars for a Degas painting, at the time a record for a work by a living artist. In 1929, Havemeyer's children donated the largest section of the collection to the Metropolitan Museum in New York, including such masterpieces as Manet's *Boating* (p. 52), Monet's *La Grenouillère* (p. 38), Degas' The *Dancing Class* (p. 44) and Cézanne's *Gulf of Marseilles* (p. 98).

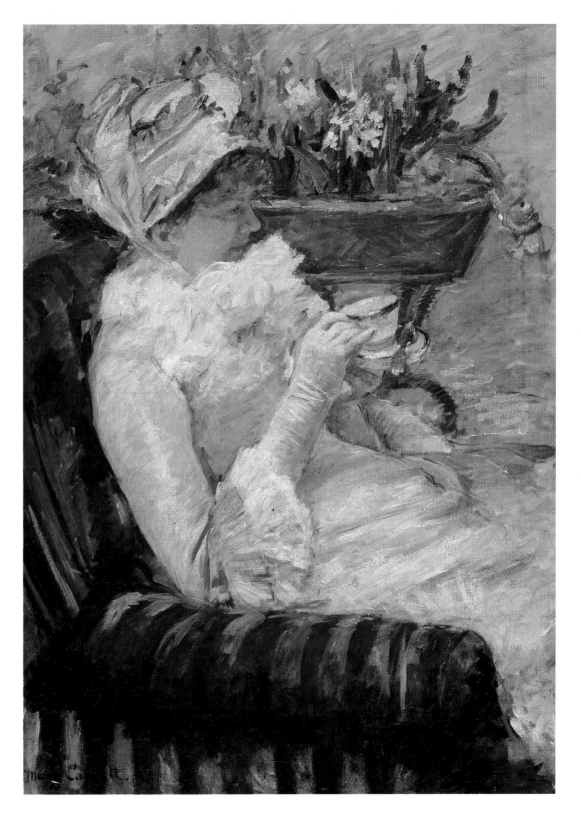

The Cup of Tea, 1880/81, oil on canvas, 92.4 × 65.4 cm, New York, The Metropolitan Museum of Art, from the collection of James Stillman, gift of Dr Ernest G. Stillman, 1922

28 AUGUSTE RENOIR
Luncheon of the Boating Party, 1880/81

More than a decade had passed since Renoir had painted *La Grenouillère* (p. 38), but the Seine and its islands had lost none of their attraction for Parisian day-trippers. The artist also still liked to travel there. He was now drawn to the Ile de Chatou. Years later, he reminisced: 'There was such an amusing restaurant there: the Fournaise. It was a never-ending party and we were a collection of people from all different classes.' Here he made the plans for this painting. When he told his friend Baron Raoul Barbier of his scheme, the nobleman took charge, rounded up the models and organised boats for the background. In the painting, Barbier has turned his back on the table: breakfast is over, the bottles half emptied, leftovers, serviettes and fruit arranged artistically on the table. Small groups of people have formed. The baron is chatting with the beautiful Alphonsine Fournaise, who is leaning coquettishly against a railing; Monsieur Fournaise, wearing a straw hat, lets his gaze wander over his guests. At that time, the restaurant was also the favoured rendezvous of Renoir and his future wife, Aline Charigot. The seamstress from Montmartre sits playing with her dog, Bob; at the table opposite her, straddling a chair, we see the painter Gustave Caillebotte alongside the actress Ellen Andrée, who had taken it upon herself to 'give this charming peasant girl [Aline] a bit of polish'. Aline listened to her and was flattered by this sign of friendship but did exactly as she pleased. 'I did not want to lose my accent and become a phoney Parisian.'

The Italian journalist Maggiolo is leaning over Andrée. Another actress, Renoir's former lover Jeanne Samary, is standing behind them. She is either adjusting her hat or closing her ears to a gentleman who is 'as short-sighted as a mole' and who is making approaches to her. He already has his hand around her waist as if taking possession of her. Eugène Pierre Lestringuez, who was interested in the occult and necromancy, stands opposite Samary, wearing a bowler hat. The banker, patron of the arts and head of the Gazette des Beaux-Arts, Charles Ephrussi, has also shown up. He is the man with the top hat. The beautiful Angèle, a flower-girl from Montmartre, is drinking wine in front of him, with a man in profile at her side, who is assumed to be Renoir's younger brother, Edmond.

The picture is almost the same size as the *Dance at the Moulin de la Galette* (p. 66). As in that painting, Renoir collected his friends from the various social classes—from the nobility to working women—in the relaxed, carefree atmosphere he so treasured. But here, the painter is less interested in the festivities and shows much more interest in the individuals who are merrily celebrating together.

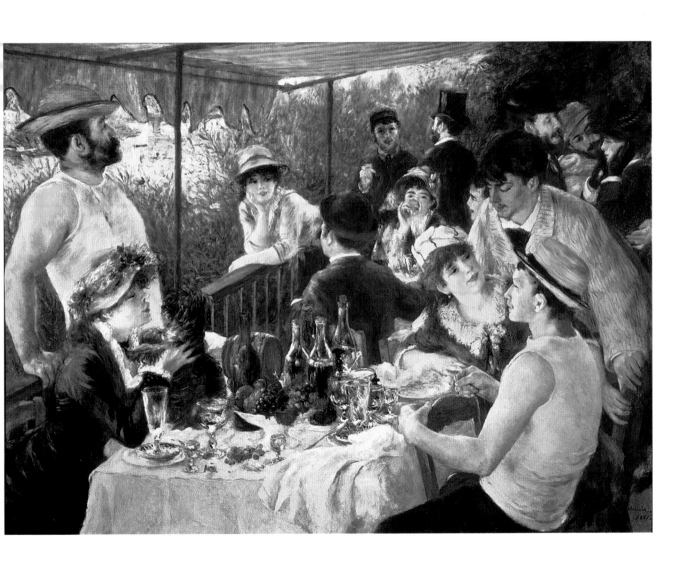

Luncheon of the Boating Party, 1880/81, oil on canvas, 130.2 × 175.6 cm, Washington, Phillips Collection

CLAUDE MONET
Bouquet of Sunflowers, 1881

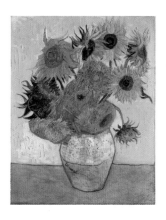

Vincent van Gogh,
Twelve Sunflowers in a Vase, 1888, oil on canvas, 92 x 73 cm, Munich, Bayerische Staats-gemäldesammlungen, Neue Pina-kothek

A *plein-air* painter is forced to cope with the whims of nature, even one who so enthusiastically hunted down the changing phenomena of light as Monet. There were, of course, some days when even he did not step outside, if the weather was too bad or his health unstable. On such days, Monet did not just sit around doing nothing, he painted still-lifes. Most were created between 1880 and 1882, and *Bouquet of Sunflowers* is undoubtedly an outstanding masterpiece.

The bunch of flowers rises magnificently out of the slender vase to explode like a small fireworks display in front of the blue-orange background. These flowers, with their leaves tumbling down like a cascade, lead a fiery life of their own. Although they were painted in the motionless atmosphere of a room, one has the feeling that the flowers have stored the wind and changing light which they were exposed to out of doors and brought them into the room.

It is not known if Van Gogh ever saw Monet's painting. In a single week in August 1888, he painted four bunches of sunflowers 'with the same enthusiasm as somebody from Marseilles eats his bouillabaisse'. Van Gogh chose different backgrounds for the bouquets—light yellow, dark royal-blue, turquoise—in order methodically to examine the harmony between these colours and the yellow of the flowers. During the work, he had the idea of hanging the *Twelve Sunflowers in a Vase* as a decoration in a planned joint atelier. Van Gogh had invited Gauguin, whom he greatly admired, to join him, and when Gaugin saw the sunflowers, he considered them better than Monet's. In a portrait of the Dutch painter and a text which was printed in 1894 under the title of *Still-Life*, Gauguin stylised the artist as the 'sunflower painter'. 'In my yellow room: sunflowers with purple eyes on a yellow background; they bathe their feet in a yellow pot on a yellow table. In a corner of the painting, the artist's signature: Vincent. And the yellow sunlight which streams into my room floods all this blossoming with gold and, from my bed, when I wake up in the morning, everything appears wonderful to me. / Oh yes, he loved yellow, good old Vincent, that Dutch painter; the sunshine which warmed his soul; in fear of the fog.'

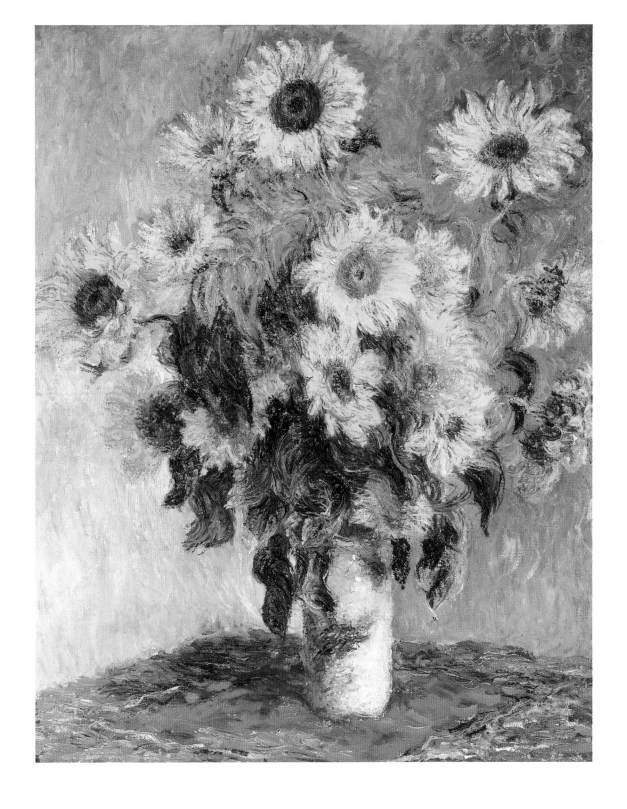

Bouquet of Sunflowers, 1881, oil on canvas, 101 × 81.3 cm, New York, The Metropolitan Museum of Art, H. O. Havemeyer Collection, bequest of Mrs H. O. Havemeyer, 1929

30 EDOUARD MANET
A Bar at the Folies-Bergère, 1882

The Folies-Bergère was 'a theatre that was not a theatre; a promenade where one remained seated; a drama one did not have to pay attention to, performed by two thousand men who smoked, drank and had fun and seven to eight hundred women who offered themselves so lightheartedly in a manner which could not be bettered'. The wealthy artist, Manet, often visited this erstwhile fashionable entertainment palace and finally painted this enigmatic picture. It was to be the last one he submitted to a Salon before his painful death in 1883.

Manet made sketches at the site in preparation for the painting; the bar was located on the first floor to the right of the stage. Then he asked the barmaid, Suzon, who really worked in the Folies-Bergère, and his friend, the military painter, Henri Dupray, to pose for him in his studio. The composition which was originally created is quite straightforward: barmaid and client, turned towards each other, are deep in conversation. This is not only shown in the preserved sketches but also in x-ray photographs of the completed painting.

Manet eventually decided to make the situation more ambiguous and to paint a multi-perspectival picture. In the centre of the mass of people reflected in the mirror, the waitress in her delicate costume appears absorbed, lost in her own thoughts, gazing into the void, infinitely alone in the midst of the drinking, eating, smoking crowd who are watching, more or less riveted, the lady on the trapeze who can just be seen at the upper left.

However, the reflection behind the woman looking to the front in the middle of the picture, causes confusion: the objects which are arranged on the marble bar to form exquisite small still-lifes are shown arranged differently on the polished surface in the background. The woman is not turned towards the man. Is she pondering over a previous encounter with a client which the viewer can imagine? Is she thinking about her life, her profession? She is the only one who is stable, her gaze, her soul; life rushes past her like the reflected movements of the many visitors to the Folies-Bergère.

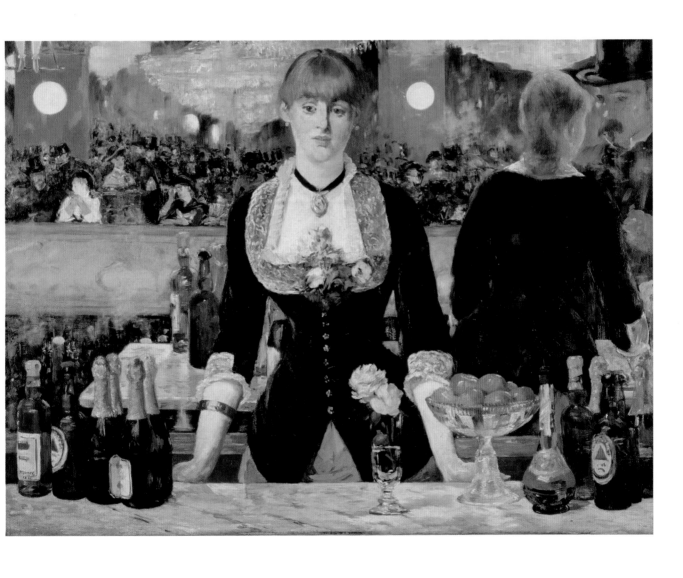

A Bar at the Folies-Bergère, 1882, oil on canvas, 96 × 130 cm, London, Courtauld Institute Gallery

31 CLAUDE MONET
The Manneporte (Etretat), 1883

Monet, who had spent his childhood in Le Havre, often visited the north-west coast of France later in his life. Between 1883 and 1886, he travelled to the fishing village Etretat several times and often painted the seashore with its chalk cliffs and fascinating rock formations, 'a terrifying, unsettling but, at the same time, fascinating landscape' which the painter 'immediately found attractive'. He painted the Manneporte rock doorway several times in order to capture the fleeting light effects. He changed his canvas whenever clouds darkened the sun and again when it re-emerged, always starting work anew to be able to depict the changing illumination: 'In order to reproduce everything, one would need to paint with both hands on hundreds of canvases,' one of Monet's ideas which later almost turned into an obsession (see *Cathedral of Rouen*, pp. 112–113).

One day, the writer Guy de Maupassant accompanied Monet on his search for motifs near Etretat and later reported on it in his article, 'The Life of a Landscape Painter': 'In reality, he was no longer a painter, he had become a hunter. He walked, followed by children who carried his canvases—five or six canvases which showed the same scene at different times and with different effects. He took one after the other, laying them aside as the sky changed. The painter lay in wait in front of the subject, on the lookout for sunshine and shadows, caught a ray of sunlight or a passing shadow with a few brushstrokes and, disdainful of anything false or common, transferred them to his canvas with great mastery. In this way, I saw how he caught hold of a glittering twilight on the steep white coast, capturing it in a stream of yellow tones which miraculously reproduced the overwhelming effect of this unfathomable, dazzlingly shimmering light. On another occasion, he snatched a handful of a violent rainstorm thrashing down on the sea and hurled it onto the canvas. And it was really rain, which he had painted, nothing more than a rainy veil over the waves, the rocks, and the sky which, in the downpour, could hardly be distinguished from each other.'

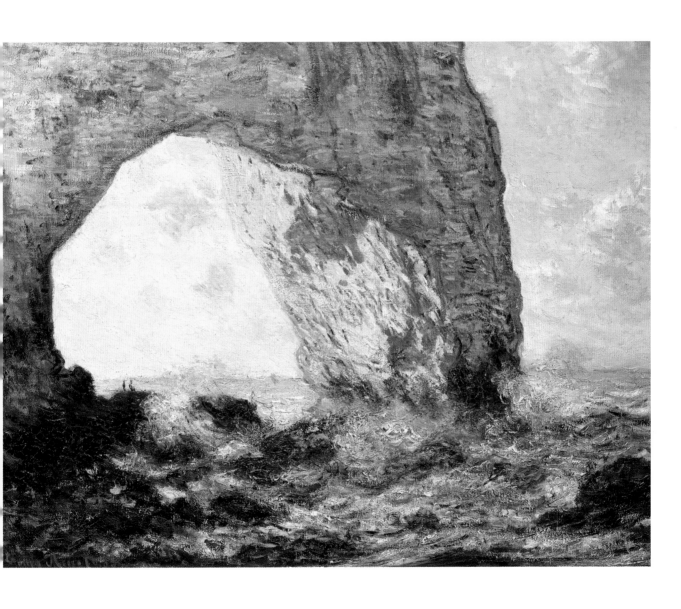

The Manneporte (Etretat), 1883, oil on canvas, 65.4 × 81.3 cm, New York, The Metropolitan Museum of Art, bequest of William Church Osborn, 1951

32 AUGUSTE RENOIR
Dance in the Country/Dance in the City, 1883

In the evening, the chairs on the terrace of the Fournaise Restaurant (see *Luncheon of the Boating Party*, p. 84) were pushed aside. One could always find someone willing to play the music for the 'dance in the country'. The sound of the piano can be heard through an open window. A couple, carried away by the music, has completely forgotten their meal on the table. The woman, Aline Charigot, is exuberant, relaxed, her face slightly flushed as she gleams happily at the crowd. Renoir's future wife was a 'divine dancer of the waltz'. Her partner, who presses the voluptuous beauty longingly against him, concentrates on her completely, inhales the perfume of her hair, maybe even whispers seductively into her ear. In his passion, his hat has fallen to the ground. They are united in joy, in the eroticism of the moment.

The *Dance in the City* is completely different. The restrained distance of the two dancers appears artificial—as artificial as plants in a hothouse. Their movements may not, cannot, be passionate; that is made impossible by the train of the woman's dress. Here, as in the countryside, a Parisian gentleman, Paul Lhote, was the model for the man. A former marine officer, he was now a journalist and lover of women and art. Renoir shows the contrast between rural and urban dance pleasures not only through his choice of warm and cool colours but also through the different types of women he depicts: in the countryside, the buxom one and, in the city, the slender, charming creature who looks as delicate as fine china. The woman whom Lhote is holding in his arms is Marie-Clémentine (called Suzanne) Valadon. The seventeen-year-old made a living sewing bed linen and was exceptionally beautiful. Many different kinds of painters, including Renoir, Puvis de Chavannes, and Henri de Toulouse-Lautrec, were fascinated by her and she was the model and lover of them all. When she posed for this painting, she was pregnant, but maybe did not know herself by which lover. Her affair with Renoir ended in 1883. It was the painter's custom to give his lovers one final portrait as a farewell present. There are several of them . . . Suzanne wanted a smaller version of the third dancing picture from the period *The Dance in Bougival*, where she spins just as vivaciously as Aline Charigot in the *Dance in the Country*. Suzanne Valadon herself became an artist. Her drawings even convinced the surly Degas. Her son was also to become a painter, world famous under the name of Maurice Utrillo.

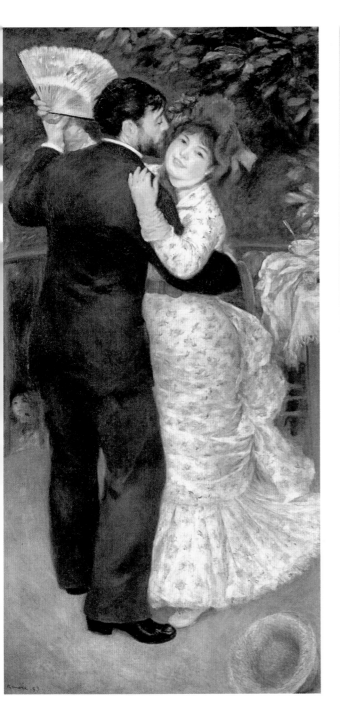
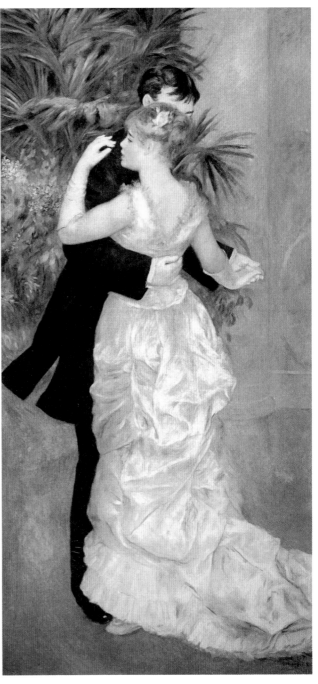

Dance in the Country (Dance at Chatou), 1883, oil on canvas, 180.3 × 90 cm, Paris, Musée d'Orsay

Dance in the City, 1883, oil on canvas, 179.7 × 89.1 cm, Paris, Musée d'Orsay

33 MAX LIEBERMANN
Beer Garden in Munich, 1884

Liebermann was fond of the paintings of the Barbizon artists. He was fascinated by Corot and Daubigny (p. 15) but he most liked Jean-François Millet's paintings of country people at work. It is no wonder; at that time, Liebermann was painting similar subjects with earthy colours. His *Women Plucking Geese*, for example, was a scandalous success. This work not only labelled him as the 'apostle of ugliness' but also brought him the money with which he set off for Paris and Barbizon in 1873. He wanted to visit Millet, whom he so admired, but the Frenchman refused to meet him: memories of defeat in the Franco-Prussian War were still too fresh. The German was confronted with rejection and reserve wherever he went, and he never really felt at ease during his five-year sojourn in Paris.

In 1878, the Munich 'prince of painting', Franz Lenbach, convinced Liebermann to settle in the Bavarian capital, which was the German artistic metropolis of the time. His background was also a problem in Munich: The parliamentarians of the Bavarian Landtag denied him the right, as a Jew, to portray Jesus as straightforwardly as he had done. In his painting *The Twelve-Year-Old Jesus in the Temple,* he portrayed Jesus as a little rascal in the midst of the scribes.

However, Liebermann remained in Munich until 1884. Towards the end of his stay, he made several sketches in the garden of the Augustinerkeller and used them for his painting, *Beer Garden in Munich*. It is a beautiful summer's day and a brass band is playing. People of all ages and from all social classes have come together: the bourgeois man with his cigar and sideburns, Bavarian infantrymen, men in top hats, bowlers or bare-headed, a nurse with a child, old women wearing bonnets, young ones with cheeky hats, children in their Sunday best. Mugs of beer are emptied, stories told, people observed, though there is no trace of exuberance, scarcely a smile to be seen, no laughter. On the other hand, the colours chosen by Liebermann are cheerful and the painting bright. Rays of light filter through the foliage and appear—typically impressionistic—as patches on the people and the ground.

This picture marked a turning point in the artist's work, away from the sombre, heavy painting of poor people to the brighter palette which he often used to depict leisure-time activities. Gradually, an increasing number of Impressionist elements found their way into his work. Of course, the French public found his pictures too run-of-the-mill; they preferred detailed depictions of society in bright, clear colours to the more radical approach of 'their' Impressionists. Liebermann was a success at the Paris Salon and was even awarded a medal in 1881, the same year as Manet but, just as Millet had done, Manet also rejected Liebermann when the German requested to make his acquaintance. Manet explained that he valued Liebermann's paintings so much 'that he would have to receive him, as a person, with the appropriate respect—but, as a French patriot, that would not be possible with a German'.

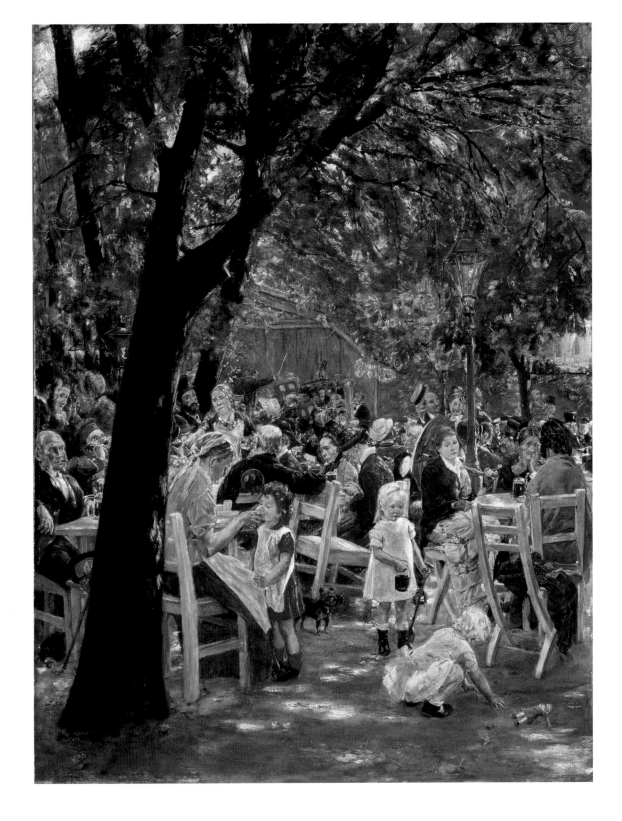

Beer Garden in Munich, 1884, oil on wood, 95 × 68.5 cm, Munich, Bayerische Staatsgemäldesammlungen, Neue Pinakothek

34 GEORGES SEURAT
A Sunday on La Grande Jatte, 1884–86

Seurat was called 'a chemist' by Gauguin and 'a notary' by the sharp-tongued Degas. He was indeed more like a scientist or lawyer than an unconventional bohemian. His contemporaries described him as formal, always impeccably dressed, serious and absolutely discreet. He was also concentrated and persevering—that was precisely how the 'inventor' of Pointillism had to be. A visit to the Fourth Impressionist Exhibition in 1879 was decisive for the nineteen-year-old Académie pupil Seurat. He felt drawn to the new style and left his teacher; his goal was to transform the fleeting, subjectively arbitrary style of Impressionist painting into something objective and permanent. In this regard, he was similar to Cézanne.

Even during his time at the Ecole des Beaux-Arts, he had shown an interest in scientific colour theories. Seurat made a precise investigation into the harmony of the tones in the paintings of the great colourist Delacroix and was convinced that he could recognise the 'strictest implementation of scientific principles'. It was already known that colours made a stronger effect when they were mixed 'in the eye of the viewer' than on the artist's palette—something to which the writer Charles Baudelaire also drew attention. Seurat concluded that the brilliance of a painting was greatest when pure colours were placed, point by point, alongside each other. He transferred these findings to his paintings, including to the largest, *A Sunday on La Grande Jatte*, which is regarded as the manifesto of Pointillism.

The bathing island La Grande Jatte lies in the Seine not far from Asnières. Seurat went there almost daily: he made sketches of people strolling, day-trippers, and the surroundings. It can be assumed that Seurat proceeded with this ambitious project as he had with previous works. He worked on various elements of the composition individually and then fine-tuned it until he was satisfied.

Seurat started working on his painting parallel to all the preparations he was making. It was painstaking work, for he had to tackle almost six square metres. For hours on end, he stood on a ladder, placing spot after spot of pure colour next to each other. In his mind he held an exact idea of the desired overall impression.

The painting was shown at the Eighth Impressionist Exhibition, which was also the last. Monet, Renoir, and Sisley refused to participate because of Seurat. *La Grande Jatte* met with the greatest interest and, naturally, became a scandal: 'If one were to remove the coloured fleas which cover his figures, one would find nothing beneath them, no thoughts, no soul, nothing. . . . I greatly fear that it is made of too much technology, too much system, and not enough sparkling fire, not enough life.' Seurat's and the critic's approaches were completely different: the painter was aiming to produce dazzling colours through the use of scientific knowledge, not to reproduce sparkling life. When asked if his painting had a deeper meaning, his reaction was vehement. 'No, I just use my technique. That's all!' was his answer.

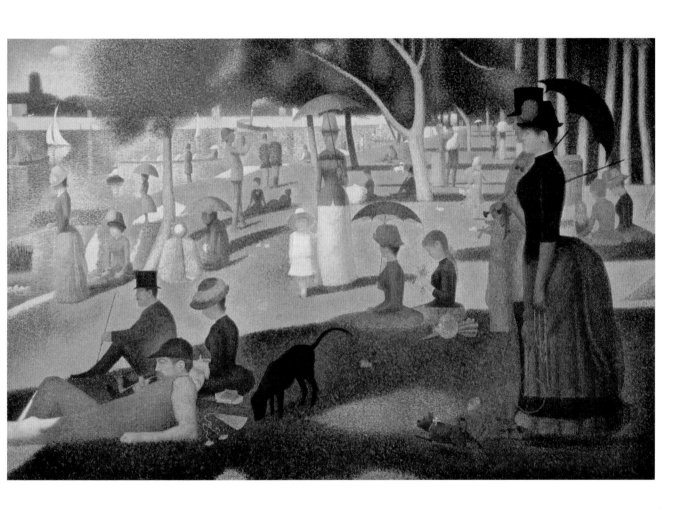

A Sunday on La Grande Jatte, 1884 – 86, oil on canvas, 207.5 × 308.1 cm, Chicago, The Art Institute of Chicago, Helen Birch Bartlett Memorial Collection, 1926

35 PAUL CEZANNE
The Gulf of Marseilles,
Seen from L'Estaque, c. 1885

'A village, a short distance from Marseilles, lying in the centre of a bay lined with rocks. It is a wonderful area. The cliffs embrace the gulf like two arms and in the distance a chain of islands appears to lock in the horizon. The sea lies there like a large pond, or a lake, shining deep blue when the weather is fine. Marseilles' sea of houses flows up the gentle hills, step by step.' This was the way Emile Zola, who had spent his childhood and youth about thirty kilometres away in Aix-en-Provence, described L'Estaque.

Throughout his life, Cézanne would escape from Paris, which was too lively for him, and return to Aix, where he was born, to paint the landscape and villages in the area, the nearby limestone massif Sainte-Victoire, and the coast near Marseilles. The southern landscape particularly suited him because 'there, the vegetation never changes. There are olive trees and pines which never lose their foliage.' The change in the seasons hardly leaves any traces. That was important for Cézanne, because he painted slowly: he often needed months, or even years, to complete a painting, repeatedly circling around one and the same motif. It was not his intention to grasp one moment and immortalise it on his canvas, as Monet did. Cézanne was attracted by the 'sky and the immortal aspects of nature'; he wanted to 'turn Impressionism into something as solid and permanent as the art of the museums'.

In a letter to Pissarro, who had introduced him to *plein-air* painting, in 1876, he wrote that the landscape near L'Estaque appeared to him to be flat and without depth. 'Here, it is like a playing card. Red roofs in front of the blue sea: The sun here is so terrifying that it makes all objects stand out as silhouettes, not just in black and white, but also in red, brown and violet. I could be mistaken, but it seems to me that this is the opposite of modelling.' Cézanne produced a feeling of depth not through a graduation of colours but through the contrast between warm colours (red and yellow), which appear to approach the viewer, and cold ones (blue and green), which appear to withdraw. His goal was not an illusionary image but the construction of an art world parallel to reality. The permanence of objects, their absolute expression, is what he was looking for. At the time of Cézanne's first solo exhibition, when the artist was almost fifty-seven years old, the critic Geffroy wrote that 'he is extremely fanatical about truth; fiery and naïve, austere and nuanced'. And he prophesied that Cézanne 'will come into the Louvre'.

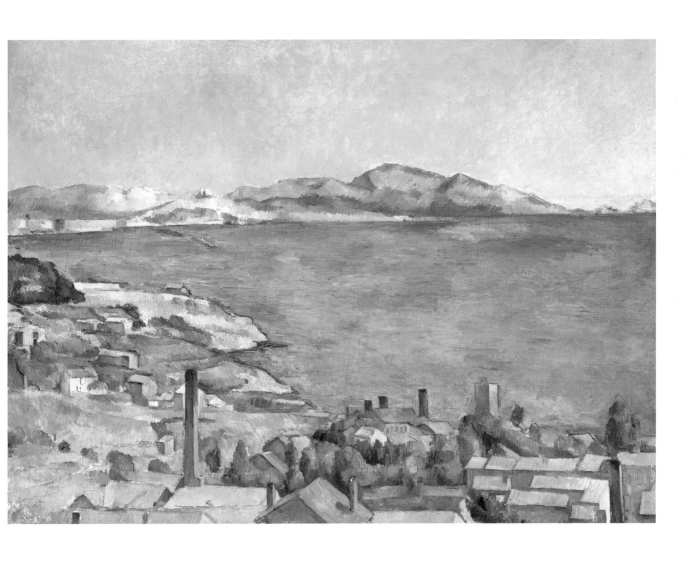

The Gulf of Marseilles, Seen from L'Estaque, c. 1885, oil on canvas, 73 × 100.3 cm, New York, The Metropolitan Museum of Art,

H. O. Havemeyer Collection, bequest of Mrs H. O. Havemeyer, 1929

36

PAUL GAUGUIN
Breton Peasant Women, 1886

After several adventurous years at sea, Paul Gauguin settled into the bourgeois existence of a stockbroker. He had a fine house in the suburbs of Paris, a happy marriage, and five children. A hobby painter himself, from the beginning of the 1870s he had been buying works of art, including paintings by the Impressionists. Pissarro became his mentor and Gaugin took part in five of their exhibitions. His works sold quickly and the idea of supporting his family from his art began to form. The loss of his place of employment as a result of the 1882 stock-exchange crash was almost like an omen. In spite of resistance from his Danish wife, he now devoted himself completely to painting.

However, the difficult economic situation also had an effect on the art market: Gauguin was able to sell very little and his resigned wife decided to return with the children to her family in Copenhagen. Gauguin accompanied her but could not stand it for long and returned to Paris with his six-year-old son, Clovis, where they soon found themselves living in impoverished circumstances. The five francs which Gauguin earned daily as a billposter were not sufficient. But Gauguin did not give up his artistic adventure and turned his back completely on his family.

In summer 1886 he fled from expensive Paris and went to Pont-Aven in Brittany. 'I love Brittany, here I find something savage, primitive. When my wooden shoes resound on the granite ground, I perceive that dull, muffled tone which I am striving for in my painting.' He loved looking at the picturesque costumes of the Breton women and they became an often-repeated motif.

In this picture, the peasant women lean and stand gossiping at one of the low walls which mark the borders of the individual properties in Brittany—an everyday snapshot of simple, rural life. The importance of the momentary situation and its depiction was the aspect of Impressionism which fascinated Gauguin because a 'profound feeling can be instantly interpreted'. But, as he continued: 'I meditate on it and strive for its simple form.'

Gauguin was attracted by the primeval and Brittany soon became too tame for him; he was seized by the burning desire to escape from civilisation. He finally shipped to French Polynesia, where he lived on Tahiti and the Marquesas and developed his two-dimensional style of painting. Though he travelled thousands of kilometres, strangely the artist always stayed within the French sphere of influence, where he was once again confronted by civilisation in the form of the colonial administration against which he polemicised, as he did against the Catholic clergy.

When he died, the local bishop was not in the least unhappy: 'The only notable event here was the sudden death of a despicable individual called Gauguin, a painter with a great reputation but an enemy of God.' However, the egocentric artist was so confident of himself and his art that even this obituary would have made no impression on him: 'I am a great artist, and I know it. And, because of that, I have had to suffer so greatly.'

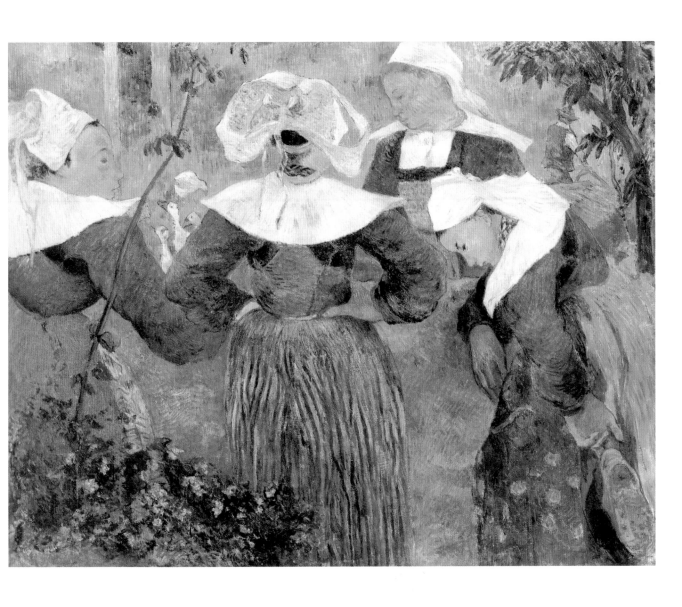

Breton Peasant Women, 1886, oil on canvas, 71.8 × 91.4 cm, Munich, Bayerische Staatsgemäldesammlungen, Neue Pinakothek

37 VINCENT VAN GOGH
Terrace of a Café at Night, 1888

Van Gogh was a failure as a dealer in art and books, as a teacher and lay preacher. He decided to become a painter and conscientiously practised drawing before taking a brush and, initially, very dark colours in hand. After he moved to stay with his brother, Theo, in Paris in 1886, he studied in the atelier of the Académie painter Fernand Cormon, but only stayed there for three months. In the meantime, Theo, who was active as an art dealer, had made him acquainted with Impressionist paintings and painters. Eventually van Gogh became fascinated by the clear colours and *plein-air* painting and was convinced 'that the study of Impressionism is now just as important as visiting the Parisian studios formerly was'.

He did not stay long in the French capital but it left indelible traces on his painting, a foundation on which he could build. Van Gogh left Paris in 1888 so that 'I do not have to see so many painters who, as human beings, I despise'. His goal was Arles, in Provence. He was enthusiastic about Japanese woodcuts and believed that in the south he would at least discover a pale reflection of the Asian land of his dreams. But the city received him frigidly—it was full of snow—and, in the following months, Vincent, for whom 'the contact with people, talking with them . . . is often embarrassing and difficult' suffered from loneliness. He was hardly able to overcome the difficulties posed by the local dialect. There was 'a long series of days when I did not speak to a single person, except to order a meal of coffee'.

However, Van Gogh placed great hope in Arles: he wanted to found a colony there for artists and implored Emile Bernard and Paul Gauguin to join him. He also hoped that Seurat would find the idea appealing. But initially, the work-crazy artist remained alone, painting day and night under the open skies, as the 'problem of painting nocturnal scenes and effects on the spot and at night is something which has taken a frightening grip on me'. Sometimes, he felt that 'the night is much livelier and more colourful than the day'.

In September he stayed up for 'three whole nights' and painted—without using black—a 'café from outside . . . with a terrace which is illuminated in the blue night by a large gas lantern and a section of the starry, blue sky'. Convinced that he could only escape from the conventional depiction of night with dull white light by studying on the spot, he painted the *Café Terrace* with candles on his hat and easel, causing such a stir that even the local newspaper reported on it: 'Monsieur Vincent, the Impressionist painter, is working, as he himself informed us, by the glow of the gas lanterns on one of our squares.'

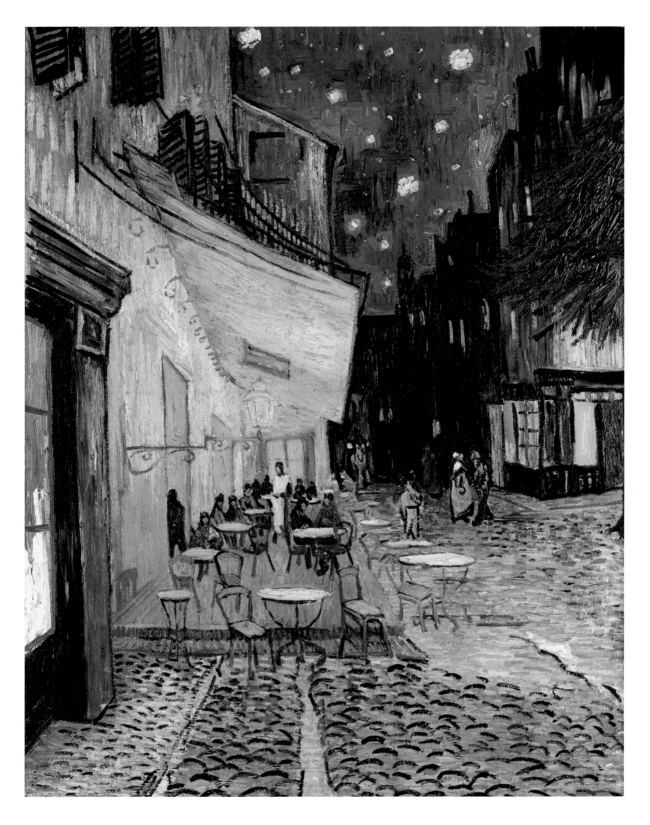

Terrace of a Café at Night (Place du Forum), 1888, oil on canvas, 81 × 65.5, Otterlo, Rijksmuseum Kröller-Müller

38 PAUL CEZANNE
Hortense Fiquet in the Red Dress, 1888–90

'One must keep in mind that he looked at his wife as if she was a piece of fruit on the tablecloth. For him, his wife's silhouette, her contours, were just as simple, or complicated, as those flowers, glasses, plates, knives, forks, tablecloths, fruit, coffee cups, and pots. He found a piece of butter just as important as the gentle contrast he perceived in the dress of his wife' (Robert Walser 1926). Who would want to be painted like a piece of fruit? Cézanne did not receive any portrait commissions. For this reason, he only portrayed people who were close to him. He was to paint nobody more often than his wife Hortense Fiquet —twenty-seven times.

Cézanne had become acquainted with the nineteen-year-old bookbinder in 1869. He kept their relationship, as well as the birth of their son in 1872, secret from his father. When Cézanne Père finally learned of Hortense and the child, he cut off the monthly financial support which had permitted his son to devote himself entirely to painting; Cézanne's old friend, Emile Zola, stepped into the breach to help the artist and his family. Indeed, it was not until shortly before his death in October 1886 that the father agreed to the marriage of Paul and Hortense. The celebration took place even though the couple had become fairly indifferent to each other and would only spend a short time together thereafter. Following his father's death, the painter often lived in his parents' spacious villa near Aix-en-Provence while Hortense and their son remained behind in Paris, where the Cézannes were able to afford an upper middle-class apartment from the considerable inheritance received from his father.

It was there that Cézanne's most impressive portrait was created: his wife in a red dress. She is seated in front of a cool blue wall, the base of which is trimmed with a bordeaux-red strip. Alongside her, we see a fireplace and its utensils, with a mirror above it and, on the other side an opulently draped curtain as a counterpart. One can make a list of these objects, but their spatial relationship is not really clear—this is particularly noticeable in the vertical lines. Cézanne had no intention of imitating, he wanted to create a 'construction following nature'. A portrait did not provide him with an opportunity for delving into the psyche of his model, it was 'merely a relational interaction between lines, physical shapes, and colours, a pretext for constructing a specific organic structure where the portrayed becomes increasingly paralysed and turns to stone' (Marcel Brion). Transforming this 'relational interaction' into a painting was the goal of his protracted labours; when his art dealer, Vollard, reminded the artist that two small sections on the canvas with his portrait were still uncovered, he said that he hoped, possibly tomorrow, '[to find] the right tone to fill in these gaps. . . . If I just fill them in haphazardly, I will have to start painting the picture again from this spot!' This caused Vollard to tremble, even if his claim that he sat 115 times for the painting is obviously exaggerated.

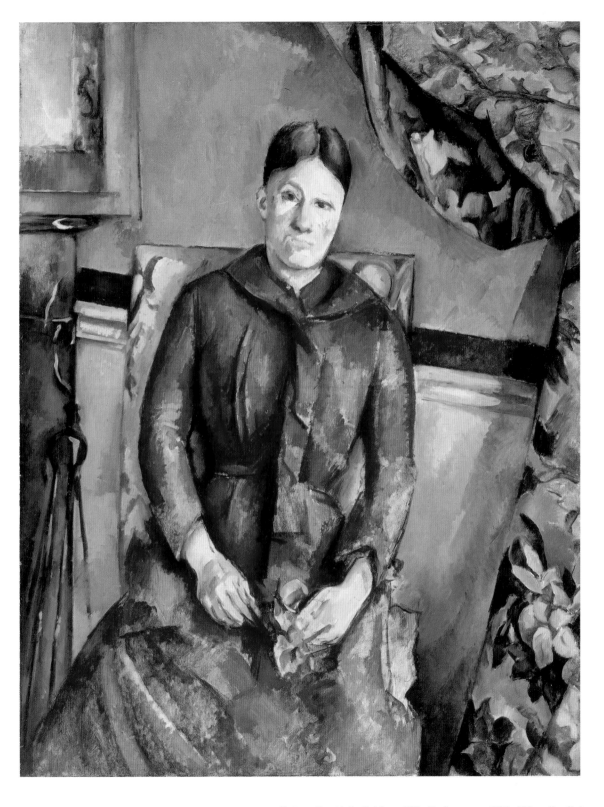

Hortense Fiquet in the Red Dress, 1888 – 90, oil on canvas, 116.5 × 89.5 cm, New York, The Metropolitan Museum of Art, The Mr and Mrs Henry Ittleson Jr Purchase Fund, 1962

39

VINCENT VAN GOGH
Cypresses, 1889

Van Gogh placed great hopes in the arrival of Gauguin in Arles. However, the closeness in the atelier, which was intended to form the core of an artists' colony, failed. On the night before Christmas Eve, 1888, Gaugin fled from a Van Gogh who was suffering a psychological crisis and was no longer in control of himself (although the attack with the razor was probably a figment of Gauguin's imagination). Van Gogh's mental problems could be seen coming. Though the joint work had initially functioned well and both artists had profited, an increasing number of quarrels had started taking place between the two egocentrics. Gauguin wanted to leave and, when his financial situation had improved—through purchases arranged by Theo van Gogh, Vincent's brother—he announced his departure.

This upset and disappointed Van Gogh and he called Gauguin 'the little Tiger Bonaparte of Impressionism . . . because his disappearance from Arles can be compared with the return of the Little Corporal of the same name from Egypt. He also went back to Paris and always left his armies in the lurch.' Nevertheless, he did not want to give up his plans for an artists' colony and, in January 1889, he wrote to Gauguin that he hoped they still liked each other enough to be able to begin anew. But they were never to see each other again.

Dogged by his fears of mental derangement, Van Gogh, who had been released from hospital on 7 January 1889 in a sound mental state, convinced himself that it was 'merely a simple artistic craze'. However, this hope was an empty delusion and, only one month later, he was admitted to hospital again. On 2 February 1889 he wrote: 'I have moments when I am shaken by enthusiasm, madness or visionary powers like the Greek oracle on her three-legged stool;' he believed that he, and all around him, were poisoned, and he heard voices. Once again, he was released but his neighbours, who saw him as 'a peculiar beast', forced him to be re-institutionalised. Van Gogh accepted and, in May, fearing new attacks, he agreed with the counsel of his trusted doctor to enter the mental home in Saint-Rémy to the north-east of Arles. He had a single room, an additional one for painting and could leave the institution's premises. In June, he wrote to Theo about the trees which give the southern landscape its typical appearance: 'I am continuously dealing with the cypresses. I would like to make something similar to the sunflower [p. 86] pictures out of it because I am surprised that nobody has painted them the way I see them. Their lines and proportions are as beautiful as an Egyptian obelisk. And their green is a particularly fine tone. It is the black spot in a landscape shining in the sun, but it is one of the most interesting black tones and I cannot think of any which would be more difficult to get right. Here, one should see the cypress against the blue—or rather, in the blue.

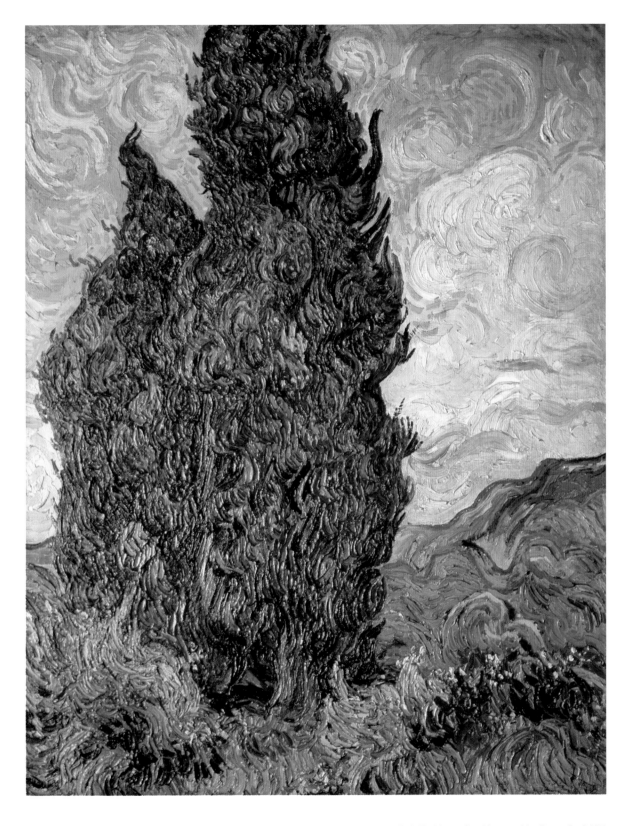

Cypresses, 1889, oil on canvas, 93.4 × 74 cm, New York, The Metropolitan Museum of Art, Rogers Fund, 1949

40

AUGUSTE RENOIR
A Young Girl with Daisies, 1889

The model for this painting is one of those creatures whom 'the gods spared the ghastly acute angle'. Renoir 'liked to see women who had a tendency to corpulence, whereas he preferred men to be slender. He was fonder of small noses than large ones and made no secret about his preference for wide mouths with full lips, which should, however, not be protuberant, and small teeth, light skin, and blond hair. "Lips like a chicken's behind are a sign of affectation, narrow lips a sign of mistrust!"', was how the painter explained this to his son, Jean.

There can be no question that Renoir's most important motifs were women who, he was convinced, were 'to blame' for his artistic existence: 'A breast is round and warm. If God had not created the breasts of woman, I would probably never have become a painter!' He understood how to portray their bodies 'like a particularly beautiful fruit', painted them the way he 'most preferred' to see them in pictures, so that he 'felt a desire . . . to run a hand over their breast or back when dealing with a female figure'.

For Renoir, an absolute patriarch, in addition to being beautiful, woman were expected to be responsible for the comforts of the home and for bringing up the children: 'Why should women be taught boring professions which men can do perfectly well—lawyer, doctor, journalist—when they are so talented in one area which men cannot even dream about: making life more pleasant?' With his charming nature, he felt that he was doing women a favour by protecting them from the rough (male) reality of the world. His wife, Aline Charigot, was satisfied with that and they led a happy married life.

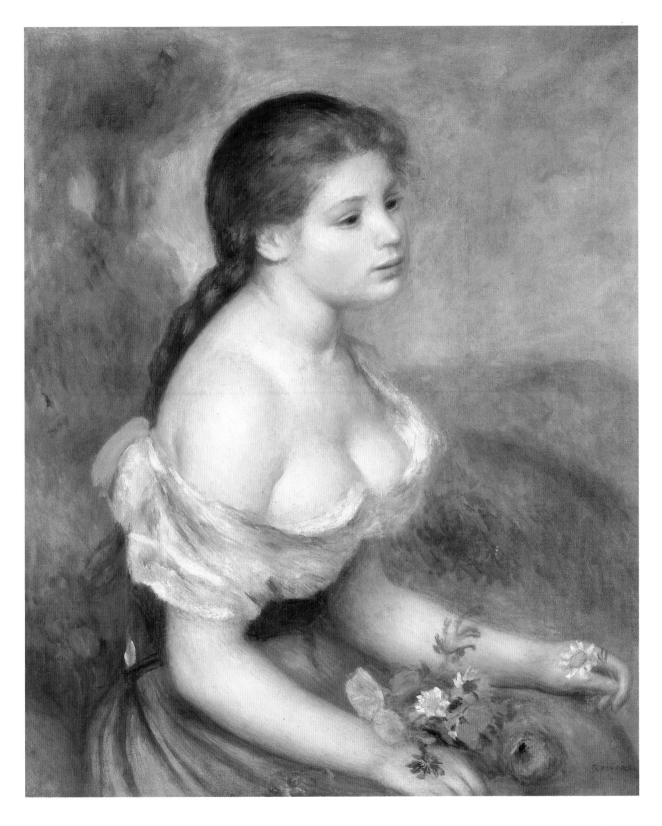

A Young Girl with Daisies, 1889, oil on canvas, 65.1 × 54 cm, New York, The Metropolitan Museum of Art, The Mr and Mrs Henry Ittleson Jr Purchase Fund, 1959

41 PAUL CEZANNE

Still-Life with Apples and a Pot of Primroses, c. 1890

During a visit to Cézanne in 1898, the painter Louis Le Baile observed: 'He spread the slightly ruffled cloth over the table. Then Cézanne arranged the fruit in a way that produced contrasts of colour and made the complementary colours vibrate, green tones against red, yellow against blue. He turned the pieces of fruit, leaned them against each other and used one- and two-sous coins to position them exactly as he intended. He then worked with all due consideration and care. One could feel that it was a feast for his eyes.'

Cézanne's desire to construct paintings was most easily realised in still-lifes. Only here was it possible for him to contemplate the arrangement of the objects to be painted, objects which would not move during the often protracted process of painting and distract him from his work. Cézanne supposedly once barked at an exhausted model: 'Apples don't move!' and confessed: 'I am afraid of female models. Those rascals just wait for a weak moment. I have always to be on my guard and, in that way, one forgets the motif!'

Cézanne had 'prepared scales for all the nuances of the colours on the palette' with which he modelled the shape of the fruit and the compressed folds of the cloth—his overall motif, as he called it. The combination of various perspectives in one painting is a remarkable aspect of many of his still-lifes.

In this *Still-Life with Apples and a Pot of Primroses*, it is noticeable that the two sections of the front edge of the table which are separated by the folds in the cloth are not in a single line, but staggered. Some of the groups of fruit appear to be seen from a lower observation point than the others, as well as the flower pot, which is seen both from the front and slightly from above. In order to show those aspects of the object which were important to him on the two-dimensional plane of a painting, Cézanne created a fracture in the central perspective—a breach which was to be taken up and further developed by the Cubists.

This picture once belonged to Monet, who was the Impressionist with the largest collection of Cézanne's works. It is one of the best out of more than 170 still-lifes. Today, it is not possible to determine exactly how many Cézanne created, because some of the paintings were cut up for admirers when it 'was not yet fashionable to sell the "atrocities" for a lot—or even a small amount—of money'. Cézanne's art dealer, Vollard, recalled that Tanguy, the paint dealer, had taken paintings by Cézanne as payment for materials and that one could 'choose from the pile of paintings, those which one wanted for the set price of forty francs for the small ones and one hundred for the large ones.

There were also pictures on which Cézanne had drawn sketches of various subjects. He left it up to Tanguy to cut them up. They were intended for those admirers who could not even afford to pay forty or one hundred francs. One could see Tanguy with his scissors selling small "motifs" when a patron handed him a louis coin and went away with "three apples" by Cézanne.'

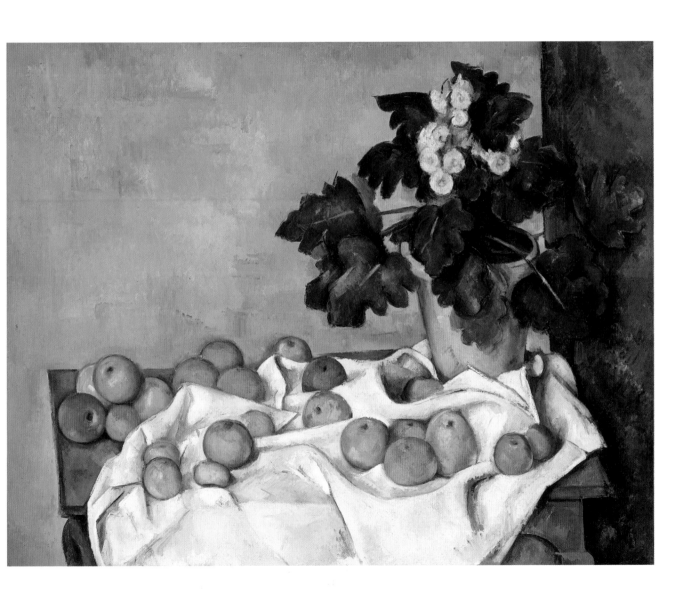

Still-Life with Apples and a Pot of Primroses, c. 1890, oil on canvas, 73 × 92.4 cm, New York, The Metropolitan Museum of Art, bequest of Sam A. Lewisohn, 1951

42 CLAUDE MONET
Cathedral of Rouen in the Evening, 1892–94

Cathedral of Rouen: The Portal (Morning),
1894, oil on canvas, 107 × 74 cm,
Riehen/Basel, Fondation Beyeler

The Portal (Sun), 1892,
oil on canvas, 100 × 65 cm,
private collection

The earth races around the sun, clouds fly past, the light changes incessantly. How can one capture a moment in time, using a brush, paint and canvas? The task was enough to drive one to despair. However, Monet had taken up the challenge in 1890 and it became an obsession. Changing his canvases whenever there was a change in the light or weather was intended to provide help. As early as 1890, he felt that painting a motif under a single lighting condition was inadmissible abstraction: 'When I began, I was just like the others and I thought that two canvases—one for cloudy weather and one when the sun was shining—were enough. But the lighting conditions changed soon after I had begun to capture those sunny moments and I realised that two were no longer sufficient to create a natural impression if one did not have the intention of assimilating various impressions in one painting.'

The artist put the dictate of *plein-air* painting—seizing the moment—into action, going to the absolute extreme. In this way, haystacks and poplars were created in series until Monet finally selected the cathedral at Rouen as his motif. He reproduced the church no less than fifty times, painting the façade from the moment when it appeared indistinctly in the hazy morning light, until it gleamed in the full glow of the sun, before being cast into the shadows by the setting sun. Here, the motif becomes almost unimportant; it becomes the bearer of the light, nothing else. Its intrinsic colour is uninteresting; only those which are decisive under the individual lighting conditions play a role.

Monet was attempting to capture a fleeting moment: one blink and everything had changed. But he still wanted to grasp it, however he could. As he correctly pointed out, the artist 'is searching for the impossible'. Impossible, because he was not able to capture the change in the impression as quickly as it occurred and because he was always after something which had already passed. He often wanted to give up the venture but he could not escape from the project, it followed him into his dreams: 'I am exhausted, I can't do any more. And, something that never happens to me, I had nightmares all night long: the cathedral collapsed on top of me, it appeared to be blue, pink or yellow.' The painter (unlike a photographer, who could almost solve the dilemma) finally took a subjective stance, once again. In 1894, he completed the paintings which he had begun in 1892/93 in Rouen, in his house in Giverny, reworking them so that they depicted one complete day, from sunrise to sunset.

Finally he exhibited twenty of the fifty pictures which show the passing of a day in the gallery of his art dealer, Durand-Ruel. Monet had decided not to sell the paintings individually, as they only created their full impact when viewed with, and alongside, each other; each was only a segment of an ensemble—one complete day. However, in the end he sold separate works for considerable prices—a compromise, as the entire project had ultimately been.

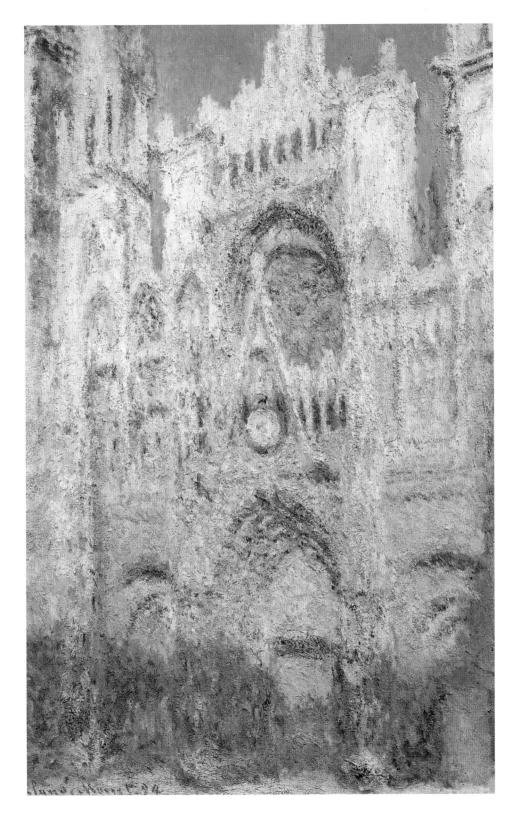

Cathedral of Rouen in the Evening, 1892–94, oil on canvas, 100 × 65 cm, Moscow, Pushkin Museum

43 HENRI DE TOULOUSE-LAUTREC

The Sofa, c. 1894 – 96

After 1892, Toulouse-Lautrec often disappeared for several days at a time. 'I have finally found girls who measure up to me.' He descended from Montmartre to visit them, the prostitutes in the expensive brothels near the Boulevard des Italiens and the Opéra. The 'little coffeepot with the big spout', as Toulouse-Lautrec called himself, had been visiting the maisons closes for some time, as he had given up hope of finding a 'normal' relationship. He lived with the girls for days on end and was allowed to observe them in their private environment; to watch them waking up in the morning, help them get dressed, see how they stood in line for the officially required medical examinations, eat with them (a gourmet, he often contributed delicacies). The girls provided him with the—obviously illusionary—feeling of being at home: 'Nowhere do I feel more comfortable.'

Toulouse-Lautrec captured his observations in the bordellos with pencil and brush. Even though the viewer feels that he is seeing a spontaneous representation of life in the maisons closes, the pictures were usually carefully prepared. In order to produce the feeling of the direct and genuine, Toulouse-Lautrec worked rapidly, using colours greatly diluted with turpentine on absorbent cardboard on which the casually painted scenes dried quickly.

At the time, there were officially 34,000 prostitutes in Paris (London, with a population twice as large, had only 24,000). It was a widespread profession, but the women who carried it out were still stigmatised, even those who were famous and sought after. Behind their backs, people whispered and sometimes even made jokes—reactions which Toulouse-Lautrec understood only too well. Like them, he was an outsider, and this bound them emotionally.

Toulouse-Lautrec did not paint these motifs during his early days in Paris. His teachers—including the 'millionaires' painter' Leon Bonnat and Fernand Cormon—were academically orientated. Cormon was less than pleased when his students—including Van Gogh, for a short period—discovered the avant-garde. Around 1885, under the influence of the urban motifs of Manet and Degas, Toulouse-Lautrec started depicting what he came across during his nocturnal forays: exuberant performances in the cabarets and dancehalls. The posters he created for the Parisian stages have become world famous and much sought after. Until the end, he honed their quality: often still in his evening clothes, he would show up at the printer's to discuss the corrections and colours for these commissioned works.

On account of his extreme alcohol consumption and dissolute lifestyle, his family cut back his allowance and he was forced largely to support himself. Despite his success with commercial art, he was never content and alcohol became a serious addiction. Ultimately, a protracted case of syphilis took its toll and he died, aged only thirty-seven years.

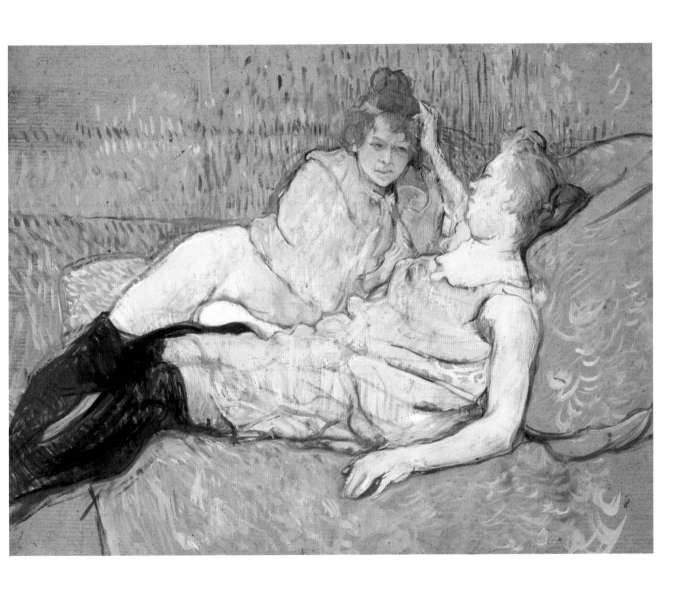

The Sofa, c. 1894 – 96, oil on cardboard, 62.9 × 81 cm, New York, The Metropolitan Museum of Art, Rogers Fund, 1951

44

CAMILLE PISSARRO
The Boulevard Montmartre
on a Winter Morning, 1897

The Boulevard Montmartre at Night,
1897, oil on canvas, 53.3 × 64.8 cm
London, National Gallery,
Sir Hugh Lane bequest, 1917

The art dealer Durand-Ruel organised Pissarro's first retrospective exhibition in 1892. A series of motifs from the area around the Parisian Saint-Lazare Station were sold quite easily and the gallery owner advised Pissarro, who was always hard-up, to paint life on the boulevards. Pissarro became increasingly interested in the topic of what was actually a hidden commission. In addition to *Boulevard Montmartre*, he created views of the Boulevard des Italiens, Avenue de l'Opéra and other locations in the French capital, in a total of seven series. At the beginning of 1897, he moved into the Grand Hôtel de Russie. An eye complaint forced him to stay inside and so he took up his observation point at his window with a view of the Boulevard Montmartre. He wrote to his son Lucien: 'I am happy that I can attempt to paint these Parisian streets which are often described as being ugly but are really silvery, so full of light and lively. . . . It is absolutely modern.' Paris had become the most modern city in Europe as a result of the transformation undertaken during the reign of Napoleon III (see also, Caillebotte, p. 70) who had the wide boulevards, which often led up to monuments, laid out. This was not merely for aesthetic reasons, or to create a speedy connection between the railway stations, but also to allow the military forces to crush any future revolts more easily.

Pissarro watched from his window, detached from the scene on the lively boulevard below. As in his earlier landscape paintings, the course of the street guides the viewer's gaze into the depths. The typical Parisian houses are shown on the left and right: shops at street level, with an elegant floor above this with higher ceilings than those of the upper floors. There are continuous balconies on the second and fourth floors and, at the top, under the roof, the dormer windows of the servants' quarters. The sections shown remain almost the same, only the weather changes, natural light is replaced by artificial illumination, carts and elegant carriages roll by, in one painting, more and, in another, fewer. The passers-by, the bustling, anonymous bit-players in the metropolis, go on their way.

It is astonishing that in the last decade of his life Pissarro dealt intensively with street scenes and city views. He had previously been almost exclusively interested in rural areas and, after moving to Eragny-sur-Epte, which was two hours by train from Paris, in 1884, also in its inhabitants at work and at the market. There were very few paintings of the city.

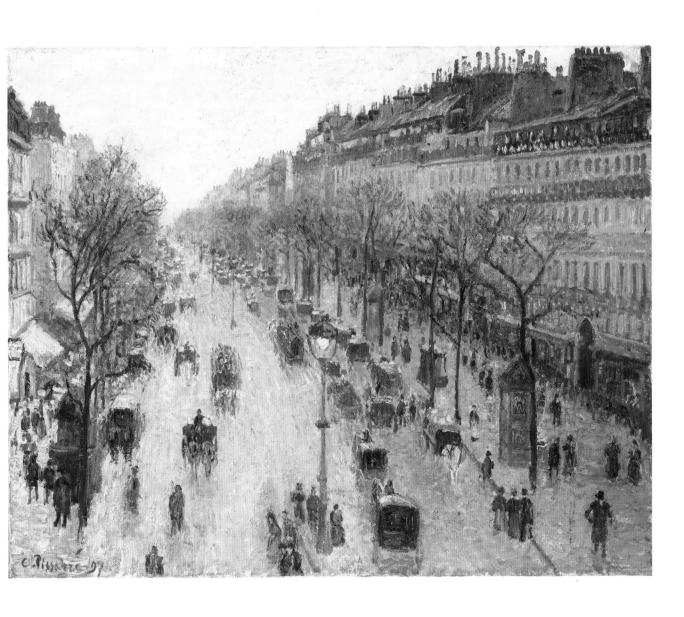

The Boulevard Montmartre on a Winter Morning, 1897, oil on canvas, 64.8 × 81.3 cm, New York,
The Metropolitan Museum of Art, gift of Katrin S. Vietor, in loving memory of Ernest G. Vietor, 1960

45 CLAUDE MONET
Bridge over a Pond of Water Lilies, 1899

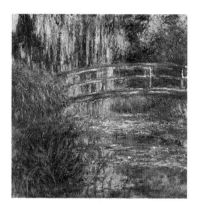

The Water Lily Pond, 1900,
oil on canvas, 90 × 92.7 cm,
Boston, Museum of Fine Arts

Giverny lies on a side arm of the Seine, sixty kilometres to the north-west of Paris, surrounded by swamps, meadows, and woods. Monet immediately fell in love with the area and looked for a spacious house with enough room for his partner, Alice Hoschedé, and her six children as well as himself and his two sons. Straightaway, he felt that Le Pressoir, probably a former cider press, was the right choice. He rented the property in 1883 and bought it seven years later, convinced that he 'would never again find such accommodations and such a beautiful region'.

The garden was overgrown when the family moved in. A keen gardener, Monet took up the challenge, developing it over the years into a gem which unfurled its blossoming splendour from spring to late autumn in a never-ending display of harmonious colours.

When Monet bought a small piece of meadow below his property in February 1893, it was with the intention of fulfilling a dream and laying out a water lily pond. To achieve this, a side arm of the Seine had to be dammed. The three hundred inhabitants of Giverny at the time were not enthusiastic, afraid that the exotic plants would pollute the water and poison their animals, which drank from the river. But Monet successfully persuaded them and he was finally able to create a pond, with an initial circumference of 200 metres, surrounded by weeping willows, poplars, bamboos, rhododendrons, irises, and other plants. He had a Japanese bridge erected at the narrowest point and painted in his favourite green. (He was infected with the enthusiasm for Japanese art which had been rampant in Europe since the 1860s; shortly before buying the property, he had admired works by Utamaro and Hiroshige in an exhibition organised by his art dealer, Durand-Ruel.) To the visitors at the time, Monet's water lily pond appeared to be quite Asian, not only because of the bridge but also the water lilies, which were quite rare in those days. As financial success finally started to make itself felt, he was able to pay ridiculous prices for valuable plants and employ as many as six gardeners to work for him, one of whom was solely responsible for trimming the water lilies into the shape of an island and cleaning the surface of the water every day.

The garden became Monet's favourite motif. He painted the pond with the bridge for the first time in winter 1895; many paintings were created in 1899. In them, the arch of the bridge appears so close that it is cropped in the picture. Its delicate curve is reflected on the surface of the water with the magnificently blossoming water lilies. There is only a hint of sky through the foliage of the trees, which is almost exclusively shown as a reflection.

Since 1897, Monet had planned a permanent interior decoration of water lily paintings as he always regretted it when his series were broken up by the sale of individual pictures. However, only in 1927 was this *Décoration des Nymphéas* to become reality, in the Parisian Musée de l'Orangerie, where the works can still be admired today.

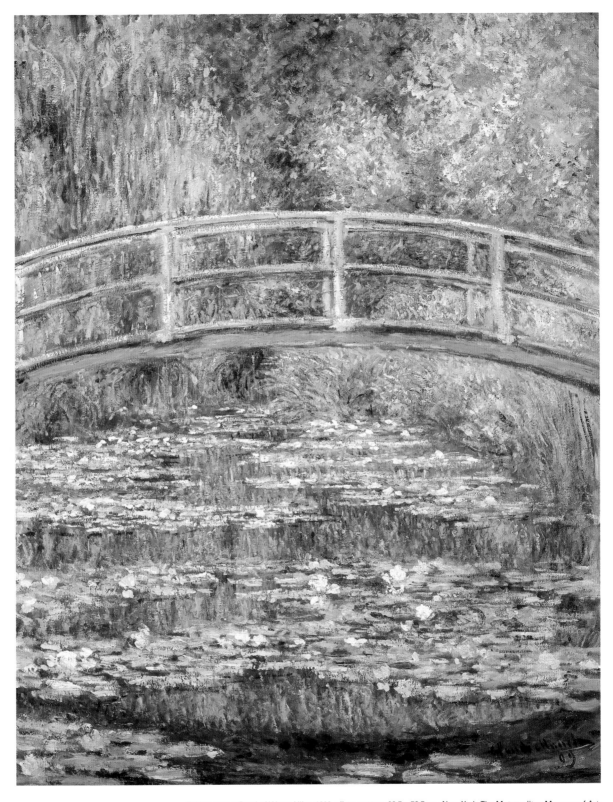

Bridge over a Pond of Water Lilies, 1899, oil on canvas, 92.7 × 73.7 cm, New York, The Metropolitan Museum of Art,
H. O. Havemeyer Collection, bequest of Mrs H. O. Havemeyer, 1929

46

MAX LIEBERMANN
The Parrot Man, 1902

After 1871, Liebermann travelled frequently to Holland where he was fascinated by the art and landscape. He regularly visited the Artis Zoo in Amsterdam, where an avenue of parrots led to the cages and enclosures of the animals. Birds sat on their swings to the left and right, hoping that the visitors had bought peanuts at the entrance to feed them with.

Ever since 1881, Liebermann had been fascinated with depicting this path. It was possible for him to combine two motifs which he often painted: a tree-lined street with light making its way through the foliage of the trees, and people taking part in their leisure-time activities in a form of organised nature. Several pictures of the 'parrot avenue' were created after making sketches. In some, finely dressed, strolling women and children form the focal point, but here it is the keeper who collects the parrots in the evening and takes them to their protective aviaries. The feathers of the macaws create a magnificently colourful display which contrasts perfectly with the muffled brown and green tones of the trees and path.

At the time of this painting, Liebermann had progressed from being the 'apostle of ugliness' to one of the most sought-after portrait painters, and the most fervent defender and champion in Germany of the Impressionists (whose pictures he had previously been able to 'make neither head nor tail of'). Now, despite their rising prices, Liebermann was able to indulge in his passion for their works, as his father, who considered a simple millionaire a pauper, had left him and his brothers a fortune running into millions. Liebermann's collection of French art ultimately consisted of thirty paintings and, compared with others in contemporary Germany, was among the best, in quantity and quality, including works by Degas, Renoir, Pissarro, Monet, Cézanne, Van Gogh, and Toulouse-Lautrec, in addition to seventeen paintings by Manet. He was permanently on the lookout for ways to make his countrymen aware of Impressionist art, which had previously been rarely shown in Germany; he was the co-organiser of exhibitions of the French avant-garde in the Berlin Secession and the Cassirer Gallery and wrote essays on Degas, Manet, and Monet. In 1896 he travelled to Paris with the director of the Berlin National Gallery, Hugo von Tschudi, to buy Manet's *In the Conservatory* (p. 78) for the museum—a purchase which created an uproar in Berlin and caused him, as a Jew, to be accused of not being a true German and paving the way for over-priced, foreign art. However, his efforts opened the eyes of many of the artists of the time, including Lovis Corinth.

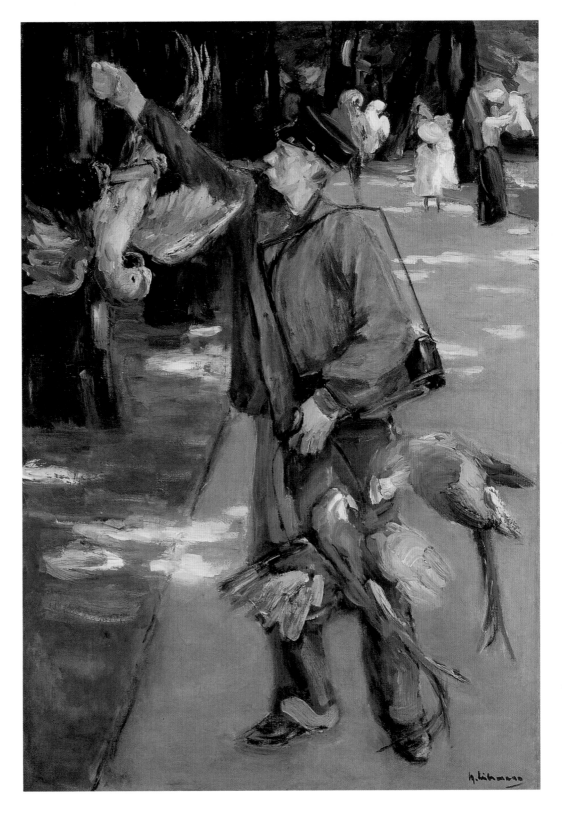

The Parrot Man, 1902, oil on canvas, 102.5 × 72.3 cm, Essen, Folkwang Museum

47

MAX SLEVOGT
The Champagne Song, 1902

Not only the music fan Max Slevogt was surprised when he heard the Portuguese opera singer Francisco d'Andrade for the first time in Munich in 1894: in a performance of Mozart's *Don Giovanni*, the baritone suddenly took control of the tempo—the conductor was too slow for him. A downright competition between the singer and orchestra was the result; the performance was the winner: carried away by the temperament of the singer, the conductor threw down his baton and applauded.

After this performance, in which he debuted as *Don Giovanni*, d'Andrade became the incomparable interpreter of the roué and bon-vivant for Slevogt and they soon developed a close friendship. In 1901, when he once again performed in this role in the Theater des Westens in Berlin-Charlottenburg, the artist decided to paint him, initially in the fifteenth scene of the first act, while d'Andrade was singing the 'champagne aria', and later in different scenes.

Brimming over with *joie de vivre* and self-confidence, the opera singer, dressed in his white costume interwoven with gold, grasps his sword with his left hand and raises his right, beaming and sure of victory. Don Giovanni's lifestyle is free and easy and it is transported in such a painting in an ideal fashion, with Slevogt making use of the means of Impressionism for the first time in his work, apart from a few landscape paintings. He stated that he had adopted this style because of Manet, whom he admired as he 'discovered, in him, that which makes the world so beautiful'. Although there are numerous sketches and studies, and he did not yet work as quickly as he did later, when he was well known and could create a painting in the time it took him to smoke a cigar (about one hour), the life-size painting appears so authentic that it could have been created directly in front of the object.

The painting was displayed for the first time at the 1902 Berlin Secession Exhibition and immediately catapulted the newcomer from Munich to fame, alongside the two most important German Impressionists, Liebermann and Corinth. As with the latter, the Berlin Secessionists also tried to recruit him and—as was also the case with Corinth—he began to doubt whether his life as a freelance artist in Munich (where he had lived since 1891 and where he had been given the nickname the 'terrible') promised a successful future. Liebermann recalls that one day he 'visited Slevogt in his atelier, because it is usually a good indication of the creator's talent if his work is confronted with strong resistance'. He was overwhelmed and Slevogt was invited to the 1899 Secessionist Exhibition in Berlin. In the same year, Slevogt's paintings were shown in the Cassirer Gallery along with works by Manet, Degas, and Puvis de Chavannes. In 1901, Slevogt—aged thirty-three—moved to the capital. Shortly after his arrival, he started working in the directorship of the Secession.

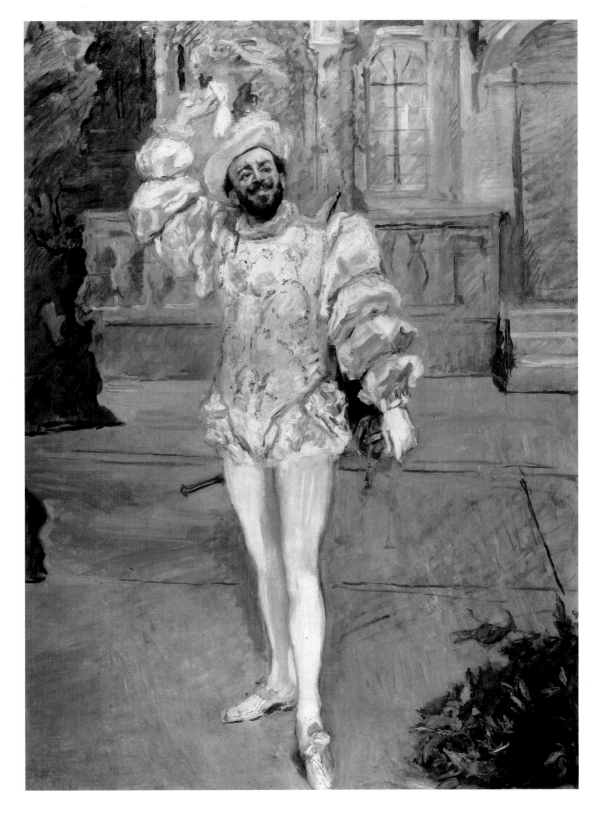

The Champagne Song, 1902, oil on canvas, 215 × 160 cm, Stuttgart, Staatsgalerie Stuttgart

48

CLAUDE MONET
The Houses of Parliament
(Effect of Fog), 1903/04

'I only like London in winter. London would have no charm without fog. Fog gives the city its amazing "breadth". This mysterious cloaking invests its massive and regular blocks with a silent greatness.' If one considers his *Impression, Sunrise* of 1872 (p. 48) and the fiendish glee with which he presented his critics with something even more hazy with his painting of the *Saint-Lazare Station* (p. 72), it becomes clear that Monet must indeed have been fascinated by the foggy English capital.

He first got to know London in 1870 when he sought refuge there from the Franco-Prussian War, but he did not begin to deal intensively with the city until 1899, when he visited it with his wife Alice and their son Jean, who was twenty years old and studying English in the British capital. The Monets stayed in the luxurious Savoy Hotel, from where they had a magnificent view of the Thames from their suite on the sixth floor. It was only natural that Monet would begin to paint excessively. However, the aspect he was most interested in, the light, was even more difficult to capture here than in his cathedral paintings (pp. 112–113).

When he returned to the city in 1900 to continue his work, he reported to his wife: 'When I got up, I was horrified to see that there was no fog, not even a slight haze. I was done for, convinced that nothing would come of my pictures. But gradually, the fires were lit and smoke and mist rose up.' The 'lighting effect would not wait' and so he dropped everything and dashed to the canvas when he discovered the hoped-for effect out of his hotel window.

But which effect was the one he hoped for? By 1 March 1900, he was already working on forty-four canvases; less than three weeks later the number had increased to sixty-five. Finally, he was surrounded by eighty canvases. When he found the one which suited the lighting effect, it was often too late: 'I hardly have one in my hands, and I have to start the next one. It was never like this before.' In January 1901, he once again returned to London and this time took on fewer canvases. However, he remained pessimistic: 'This is a country where one can never finish a painting. You never get the same effect twice. I should have made sketches, genuine impressions. . . . Instead, I have reworked one canvas as many as twenty times, disfigured it to a sketch in a few seconds.'

Each of these paintings is covered with a veil which swallows the contours and colours which Monet thought to be 'typical of London'. The views of the Thames were not completed at the site but in Monet's atelier in Giverny after 1903. He coordinated the coloration of the paintings 'because the impression of the complete series is much more important'. When they were exhibited in Durand-Ruel's gallery in May 1904 they met with stunning success, one critic even writing: 'Claude Monet is competition for the Salon, to which he is hostile.' A single artist against the major exhibition of contemporary art!

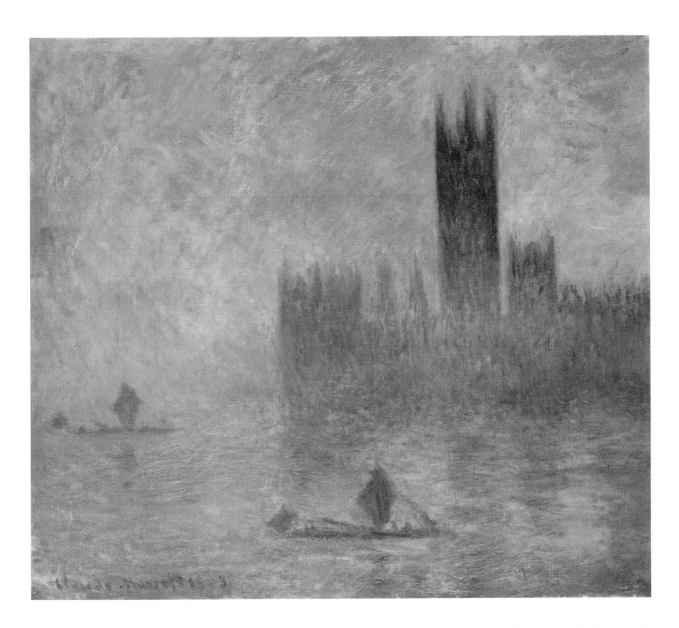

The Houses of Parliament (Effect of Fog), 1903/04, oil on canvas, 81.3 × 92.4 cm, New York, The Metropolitan Museum of Art, bequest of Julia W. Emmons, 1956

49

LOVIS CORINTH
After the Bath, 1907

'In a word, the painting is brilliant; what cheerfulness is communicated by these fresh, sunny colours!' Corinth's wife Charlotte was enthusiastic about this painting, which was created in Lychen in the Mark of Brandenburg. The relaxed, carefree feeling of the summer of 1906 shines out, shimmering with light and painted in bright colours, and brings Charlotte's recollection back to life: 'We had rented a small house and had a boat. We were actually almost always on—or in—the water . . . Wherever we felt like it, we beached the boat, took off our clothes and went for a swim. Once, when I was busy taking off my colourful stripey stockings, [Corinth] called: "Hey you, would you model for me? You look wonderful." . . . The following day, he was sitting in the boat, the easel in front of him, painting away.'

His favourite model had no problem holding poses, even uncomfortable ones, for a long time. Not only that: as no other, she knew how to cheer up her husband, who tended to self-doubt and self-torment, with her 'commanding tone of "jest, irony, and profound significance"', to amuse him and to encourage his painting through her charming wardrobe and floral arrangements. The happier the atmosphere during the sitting, the more successful the transfer to the canvas.

Charlotte not only came to Corinth as a model: she had also been his pupil shortly after he arrived in Berlin in October 1901 and opened an art school. The cheerful twenty-two-year-old and the depressive painter, who was one year older, soon became a couple and they married in 1903.

Moving from Munich to Berlin not only led to private happiness for Corinth. After his painting *Salome* had been turned down for the Munich Secession Exhibition, Walter Leistikow was right there where he was needed. The firebrand of the Berlin Secession attempted to attract the best artists to the capital of the Reich. He asked Corinth to exhibit the painting at the artists' society and prophesied that it would be 'a tremendous success'. This actually happened and Corinth moved to Berlin where he became, as he wrote in his *Autobiography*, 'an authority'. With the support of the art dealer Cassirer and the Berlin Secession, where he became a member, the 'uncorrupted, primeval natured' Corinth developed into a sought-after portrait painter. He was soon working with his kindred spirits Liebermann and Slevogt in the directorship of the Secession. The 'triumvirate of German Impressionism'—a catchy phrase which probably originated from Cassirer—turned the capital of the Reich into the leading German art metropolis.

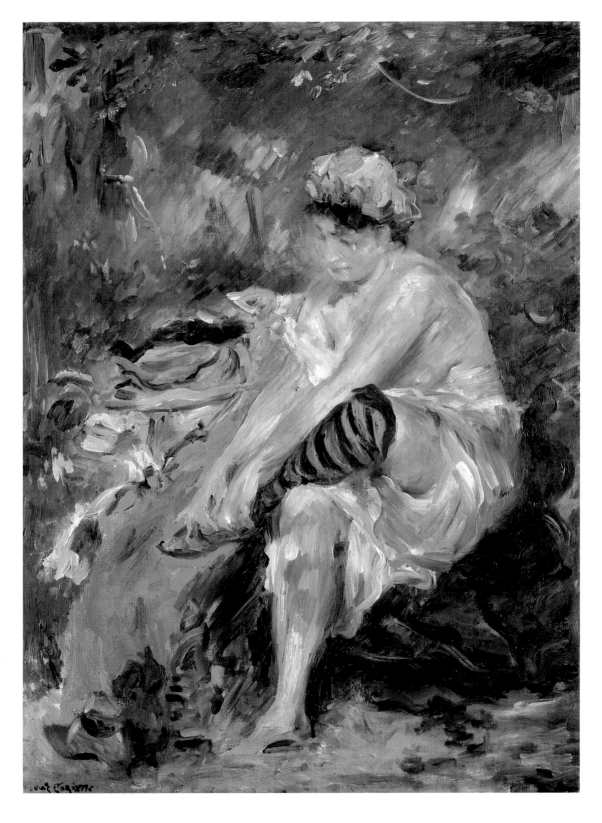

After the Bath, 1907, oil on canvas, 80 × 60 cm, Hamburg, Hamburger Kunsthalle

50 PAUL SIGNAC
The Papal Palace in Avignon, 1909

Signac was undecided: Should he become an architect or a painter? However, after seeing Monet's 1880 solo exhibition in Charpentier's gallery, La Vie Moderne, he felt certain: Painting was his calling. In a letter to the revered master, Signac wrote: 'Your works were my sole models. I followed the wonderful path you opened up to us.' There is no record that Monet received his admirer; even if he did, the only advice he gave to those who wanted to learn from him was to paint a lot and then their work would improve.

Signac did not follow Impressionist painting for very long. After meeting Seurat in 1884, who was just four years his senior, Signac became enthusiastic about the painter's colour theory. They became close friends and Signac soon started implementing Seurat's principles of Pointillism in his paintings. When Seurat died in 1891, at the early age of thirty-one, Signac assumed the main responsibility for the organisation of the memorial exhibition by the Société des Artistes des Indépendants. However, Seurat's work was rapidly forgotten in the years that followed; the few, pains-takingly produced paintings he had created were in private collections and hidden from the general public. Signac, as his friend's intellectual and artistic executor, felt obliged to do everything in his power to keep Seurat's work and ideas alive. He presented the maxims of the style which Seurat had developed in his book on artistic theory, *From Eugène Delacroix to Neo-Impressionism*, published in 1899.

Signac is one of the few artists who followed Seurat's methods throughout his artistic life, albeit with some modifications. When he once again saw *A Sunday on La Grande Jatte* (p. 96) in 1897, he recognised something quite unintentional: if the spots are too small, they merge and the picture appears to be covered with a grey veil.

Signac therefore used small, rectangular areas of colour in very bright tones for his motifs, as is the case with the *Papal Palace in Avignon*. The monumental construction appears to be enchanted, as weightless as a fairytale castle, in the light of the setting sun. The towers, painted using vertical rectangles, seem to be moving towards the horizontal shapes which represent the sky. The speckles which depict the glittering surface of the Rhône are also positioned horizontally like small mosaic stones. Signac placed regular brushstrokes alongside each other to form the Saint Bénézet bridge, with swirling ones to depict the plants on the banks and some small clouds. In order to create this feeling of luminosity and sense of absolute harmony Signac rejected the detailed study of nature which his former idol Monet carried out (see *The Manneporte*, p. 90): 'It is extremely difficult to paint nature perfectly, each reflection, each change in the effects which one is attempting to capture, distracts one from [the painting's] harmonies.' The technique used is not something negative which hinders the artist, but a form of 'logic, transferred to the realm of the pure, the beautiful'.

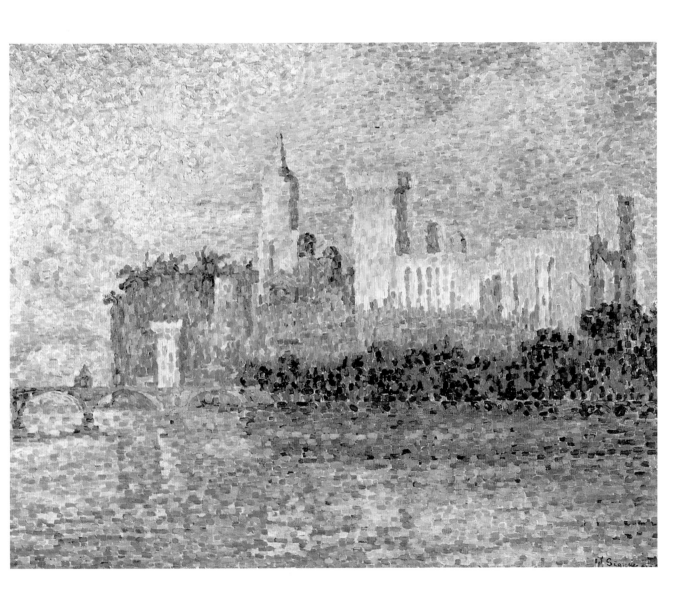

The Papal Palace in Avignon, 1909, oil on canvas, 73.3 × 91.9 cm, Paris, Musée d'Orsay

BIOGRAPHIES

Gustave Caillebotte
(1848–1894)

Caillebotte was born in Paris. After passing his law examinations in 1870, he studied at the Ecole des Beaux-Arts. In 1874, he inherited a large fortune and, thereafter, supported the Impressionists before exhibiting with them for the first time in 1876. Caillebotte played a significant role in the organisation and financing of future shows. His paintings from the 1870s depicting motifs of Paris are illustrative, with a restrained coloration. After 1880, when he moved to live near Argenteuil, he focussed on water sportsmen, painted with casual brushwork. Caillebotte bequeathed his extensive collection of Impressionist works to the French nation.

Mary Stevenson Cassatt
(1844–1926)

Cassatt was born in Pittsburgh, Pennsylvania, the daughter of a wealthy banker. As a child and young woman, she travelled to Europe with her family. From 1861 to 1864, she studied at the Academy of Arts in Pittsburgh before continuing her work in private studios in Paris in 1866. She accepted Degas's invitation to participate in the Impressionist exhibitions held after 1879 and in 1891 Durand-Ruel organised a solo exhibition. Cassatt's works were principally devoted to the subject of mothers and children. She went blind and was forced to stop painting after 1914. Her contacts and support played a major role in the spreading of Impressionist paintings in the USA.

Paul Cézanne
(1839–1906)

Cézanne was born in Aix-en-Provence, the son of a banker. He became friends with Emile Zola at the Collège Bourbon. In 1861, he gave up the law studies which he had begun in 1859 and went to Paris to devote himself to painting, moving in the circle of the Batignolles group. Cézanne took part in the first and third Impressionist exhibitions. Disappointed by his lack of success, he moved back to the south of France but frequently travelled to Paris and other French locations. He concentrated on landscapes, still-lifes and portraits. In 1895, he had his first, successful, exhibition in Ambroise Vollard's gallery. Today, his studio in Aix-en-Provence is a museum.

Lovis Corinth
(1858–1925)

Edgar Degas
(1834–1917)

Eugène-Henri-Paul Gauguin
(1848–1903)

Born in Tapiau near Königsberg (today Kaliningrad) in East Prussia, Corinth completed a four-year qualification at the academy in Königsberg and went to Munich in 1880 before moving to Paris to study at the Académie Julian from 1884 to 1887. He returned to Munich, where his paintings were received with hostility, but he was sought after by the Berlin Secession and became a member in 1899. Two years later, Corinth moved to the capital and developed into a celebrated portraitist of Wilhelmine society. Along with Liebermann and Slevogt, with whom he worked in the directorship of the Secession, he was one of the most influential German Impressionists. Following a stroke in 1911, his paintings became increasingly expressive. Numerous landscape paintings were created during his holidays in Urfeld on the Walchensee in Bavaria.

Hilaire-Germain-Edgar De Gas was born in Paris, the scion of a banker's family. He gave up his studies of law in 1855 in order to become a painter and enrolled at the Ecole des Beaux-Arts, perfecting his knowledge during a subsequent sojourn in Italy. In 1861, he became acquainted with Manet and the other Impressionists in the Café Guerbois. Around this time, he discovered his motifs, such as horse-racing and dancers, in the life of the metropolis of Paris and his works often revolved around these subjects. He participated in all the Impressionist exhibitions, with the exception of the seventh. He started to suffer from an eye disease in 1880 and finally went blind. Durand-Ruel organised a solo exhibition for him in 1893.

Born in Paris, Gauguin grew up in Peru before returning to his native city in 1872. He became a successful stockbroker, collected works by the Impressionists and painted in his leisure time. During the economic crisis of 1883 he lost his job and decided to become an artist. Camille Pissarro invited him to participate in the Impressionist exhibitions and he regularly took part after 1879. He painted in Pont-Aven, where he became the focal point of the school of the same name, on Martinique and, with Vincent van Gogh, in Arles. Emanating from Impressionism, his style became increasingly two-dimensional. In his search for the unspoiled, he travelled to Tahiti for the first time in 1891 but returned to Paris in 1893 where his solo exhibition in Durand-Ruel's gallery was unsuccessful. He left Paris for good in 1895 and spent his final years on Tahiti and the Marquesas. There is a Gauguin Museum in Papeari Village on Tahiti and the Centre d'art Paul Gauguin on Martinique.

Vincent Willem van Gogh
(1853–1890)

Born in Groot Zundert in Brabant, Holland, Van Gogh was the son of a preacher. He was a failure as a book and art dealer, teacher and preacher and, in 1880, enrolled at the Ecole des Beaux-Arts in Brussels. In 1886, he moved to Paris, to his brother Theo, who was to care for him for the rest of his life. Van Gogh studied for some months in Ferdinand Cormon's studio and became acquainted with paintings by the Impressionists. Under their influence, he changed from painting poor people in earthy colours to a brighter palette. In 1888, he went to Arles, where he intended to found an artists' colony. Gauguin visited him, but left again after two busy but enervating months, following a dispute. Suffering from repeated bouts of depression, Van Gogh had himself admitted to the psychiatric clinic in Saint-Rémy and finally moved to Auvers-sur-Oise, where he chose to put an end to his life. The Rijksmuseum Vincent van Gogh is located in Amsterdam.

Max Liebermann
(1847–1935)

The son of a wealthy Jewish family was born in Berlin. He studied in his home town, at the art academy in Weimar and, from 1873 to 1878, in Paris, under the influence of the Barbizon painters. He subsequently moved to Munich before finally returning to Berlin in 1884. Influenced by the Impressionists, his palette became increasingly brilliant, his application of paint freer. Numerous genre scenes were created on his frequent visits to the Netherlands. He became one of the founders of the Berlin Secession in 1898 and, under its influence, the centre of artistic life in Germany moved from Munich to Berlin. Liebermann became one of the most successful painters of his time, championed the French Impressionists and collected their work. He was elected President of the Prussian Academy of Arts in 1920 but withdrew in 1933 out of protest against the National Socialists and renounced his office. A museum has been installed in the last house where Liebermann lived, on the Wannsee in Berlin.

Edouard Manet
(1832–1883)

Born to well-to-do parents in Paris, Manet studied from 1850 to 1856 with the Académie painter Thomas Couture and frequently copied paintings in the Louvre. Manet developed his style at the beginning of the 1860s, devoting himself to contemporary Parisian motifs. With works such as *Concert in the Tuileries* (1862), *The Lunch on the Grass* (p. 30) and *Olympia* (both 1863), he became a model for the next generation of painters and was regarded as the spiritual mentor of the Impressionists, whom he met in the Café Guerbois. Influenced by Monet, he painted some pictures en *plein air* in the mid-1870s, where his palette became significantly lighter and his brushwork more animated.

Claude-Oscar Monet
(1840–1926)

The son of a grocer, Monet was born in Paris and grew up in Le Havre. In 1856, Eugène Boudin introduced him to *plein-air* painting on the Normandy coast. Monet moved to Paris, studied at the Académie Suisse and the Atelier Gleyre. There he became acquainted with Frédéric Bazille, Renoir and Sisley and led joint painting excursions in the forest of Fontainebleau. He was one of the initiators of the first Impressionist exhibition. Following initial endeavours in figurative painting, he soon devoted himself to landscapes. After 1871, he lived, almost exclusively, in rural areas—in Argenteuil, Vétheuil and finally in Giverny. Monet concentrated especially on the effects of light. In order to show the changes, he painted increasingly abstract series of pictures. After 1908, his eyesight worsened rapidly until he was almost completely blind. A museum is located in his house and garden in Giverny.

Berthe Morisot
(1841–1895)

Morisot was born in Bourges, the daughter of a civil servant, who also gave her painting instruction. The family moved to Paris in 1852 where she studied privately with various artists. After 1860, she was tutored in *plein-air* painting and other subjects by Camille Corot. Morisot exhibited regularly in the Salon from 1864 to 1873. After meeting Manet, she became his model and the two artists influenced each other. She married his brother Eugène in 1874. With the exception of 1879, she took part in all the Impressionist exhibitions. Her subjects were mainly bourgeois women taking care of children and engaged in their leisure-time activities.

Jacob-Abraham-Camille Pissarro
(1830–1903)

Pissarro was born in Charlotte-Amalie, the capital of the Antilles island Saint-Thomas, which at that time belonged to Denmark. He was the son of a Jewish businessman. After working in his parents' business and a sojourn in Venezuela, he moved to Paris, where he studied at the Ecole des Beaux-Arts and, later, the Académie Suisse, where he met Monet. He exhibited regularly in the Salon between 1859 and 1869. In 1866, Pissarro moved to Pontoise and, in 1884, to Eragny. He mainly painted landscapes and, towards the end of his life, devoted himself to city scenes. Pissarro was the only artist to participate in all the Impressionist exhibitions. In 1885, he advocated Neo-Impressionism and his work was characterised by that style for a period. The Musée Tavet-Delacour/ Camille Pissarro is located in Pontoise.

Pierre-Auguste Renoir
(1841–1919)

Born in Limoges into a tailor's family that moved to Paris in 1844, Renoir studied to be a porcelain painter. He became friends with Bazille, Monet, and Sisley in the Atelier Gleyre and took part in four of the Impressionist exhibitions. He devoted himself to landscape painting before becoming increasingly interested in figures and, by the end of the 1870s, he was a sought-after portrait artist. After a sojourn in Italy in 1882, his work became increasingly dominated by the line. He suffered greatly from rheumatism and in 1899 moved to Cagnes-sur-Mer near Nice, where a Renoir museum is located.

Georges-Pierre Seurat
(1859–1891)

Seurat was born into a well-off family in Paris. In 1878, he began his studies at the Ecole des Beaux-Arts, which he terminated as a result of the impact made on him by Impressionist paintings. In 1883, he was admitted to the Salon but rejected in the following year when he became one of the founders of the *Société des Artistes Indépendants*. During his studies, he had already investigated artistic theory and chromatics and developed a technique which he called Divisionism (also Neo-Impressionism or Pointillism). He became acquainted with Paul Signac in 1884 and the two took part in the final Impressionist exhibition in 1886.

Paul Signac
(1863–1935)

Born into a Parisian businessman's family, Signac decided to become an artist after visiting a Monet exhibition. He moved to Asnières, painted in *plein air* and became acquainted with Pissarro. In 1884 he was one of the organisers of the Salon des Indépendants and became a friend of Seurat's. He was impressed by his Pointillism and followed this technique in his later paintings, progressing from Seurat's small dots to broader structures resembling mosaic stones. He continued with the theory of Seurat, who had died at an early age, and wrote the theoretical essay *From Eugène Delacroix to Neo-Impressionism* (1899), which made Pointillism known in Germany and Italy.

Alfred Sisley
(1839–1899)

Sisley was born in Paris, the son of a well-to-do English businessman. His father sent him to London to do a commercial apprenticeship, where he was in 1857 fascinated by the works of Constable and Turner. He decided to become an artist and, upon his return to Paris in 1862, entered the Atelier Gleyre, where he met Renoir and Monet. Sisley only painted landscapes and preferred the areas near his homes in Louveciennes and Marly-le-Roi. After the Franco-Prussian War and his father's bankruptcy, he lived under humble circumstances. He participated in the first three Impressionist exhibitions, and in the seventh in 1882.

Max Slevogt
(1868–1932)

Slevogt was born in Landshut, Bavaria. After his studies at the art academy in Munich, he went to Paris from 1885 to 1889, where his palette became brighter. His paintings were not welcome in Munich and he accepted to the offer of the Berlin Secessionists and moved to the capital. He quickly became famous for his portraits and, along with Liebermann and Corinth, was the most important representative of German Impressionism. His work is strongly influenced by impressions gained in theatres and concert halls—he designed costumes for Max Reinhardt, among others. In 1914, he travelled to Egypt and was a war painter on the Belgian front in the First World War before becoming a professor at the Berlin Academy in 1917. There is a Slevogt Gallery in Villa Ludwigshöhe Castle in Edenkoben (Rhineland-Palatinate).

Henri de Toulouse-Lautrec
(1864–1901)

Lautrec was born in Albi, a member of one of the most aristocratic families of the French nobility. A hereditary disease handicapped his growth and he remained short and disabled throughout his life. His family encouraged his drawing talent and he studied with several Académie painters in Paris. Lautrec was an habitué of the pleasure temples of the time and captured the nightlife and its stars in numerous pictures. His advertising posters revolutionised the art form. He became addicted to alcohol and died at a young age, following a stroke. A Musée Toulouse-Lautrec is located in Albi.

PHOTO CREDITS/COLOPHON

The illustrations in this publication have been kindly provided by the museums, institutions and archives mentioned in the captions, or taken from the Publisher's archives, with the exceptions of the following:

akg-images, Berlin: pp. 55, 88, 98, 90; akg-images/Erich Lessing: pp. 24, 53, 71; Artothek, Weilheim: pp. 10, 35, 45, 83, 85, 87; Claus Hansmann – Artothek: pp. 119; Hans, Hinz – Artothek: p. 50; Joseph S. Martin – Artothek: pp.103, 97, 137, 139; Peter Willi –Artothek: p. 49; DHM-Bildarchiv, Berlin: pp. 136 centre; The Metropolitan Museum of Art, New York/Bridgeman Giraudon: p. 107, The Metropolitan Museum of Art, New York/Bridgeman Giraudon: pp. 17 bottom, 75; The Metropolitan Museum of Art, New York: pp. 14 bottom, 39, 47, 57, 81, 105, 109, 111, 115, 117, 125

Front Cover (top): Claude Monet, *Poppies*, see pp. 51; Front Cover (bottom): Edgar Degas, *The Dancing Class*, see p. 45; Frontispiece: Claude Monet, *The Portal and the Tour d'Albane at Dawn* (detail), 1893, 106 × 74 cm, Boston, Museum of Fine Arts; Vincent van Gogh, *Terrace of a Café at Night*, pp. 8–9, see p. 102; Claude Monet: *Saint-Lazare Station*, p. 28, see p. 73; p. 131: Dining Room in Max Liebermann's House at the 'Pariser Platz', Berlin; pp. 140–141: Georges Seurat, *A Sunday on La Grande Jatte*, see p. 97.

© Prestel Verlag, Munich · London · New York, 2018 (original edition published in 2007) A member of Verlagsgruppe Random House GmbH, Neumarkter Straße 28 · 81673 Munich

In respect to links in the book, Verlagsgruppe Random House expressly notes that no illegal content was discernible on the linked sites at the time the links were created. The Publisher has no influence at all over the current and future design, content or authorship of the linked sites. For this reason Verlagsgruppe Random House expressly disassociates itself from all content on linked sites that has been altered since the link was created and assumes no liability for such content.

Prestel Publishing Ltd.
14–17 Wells Street
London W1T 3PD

Prestel Publishing
900 Broadway, Suite 603
New York, NY 10003

Library of Congress Control Number: 2018932219

A CIP catalogue record for this book is available from the British Library.

Editorial direction Prestel: Anne Hagenlocher, Kira Uthoff
Translated from the German by Robert McInnes, Vienna
Copyediting: Nadia Lawrence, Antje Eszerski for bookwise GmbH, Munich
Cover design: Sofarobotnik
Design: normal industries Munich
Layout and Typesetting: bookwise GmbH, Munich
Production management: Corinna Pickart
Printing and binding: DZS Grafik, d.o.o., Ljubljana

FSC MIX Paper from responsible sources FSC® C112556 www.fsc.org

Verlagsgruppe Random House
FSC® N001967

Printed in Slovenia

ISBN 978-3-7913-8443-6

www.prestel.com

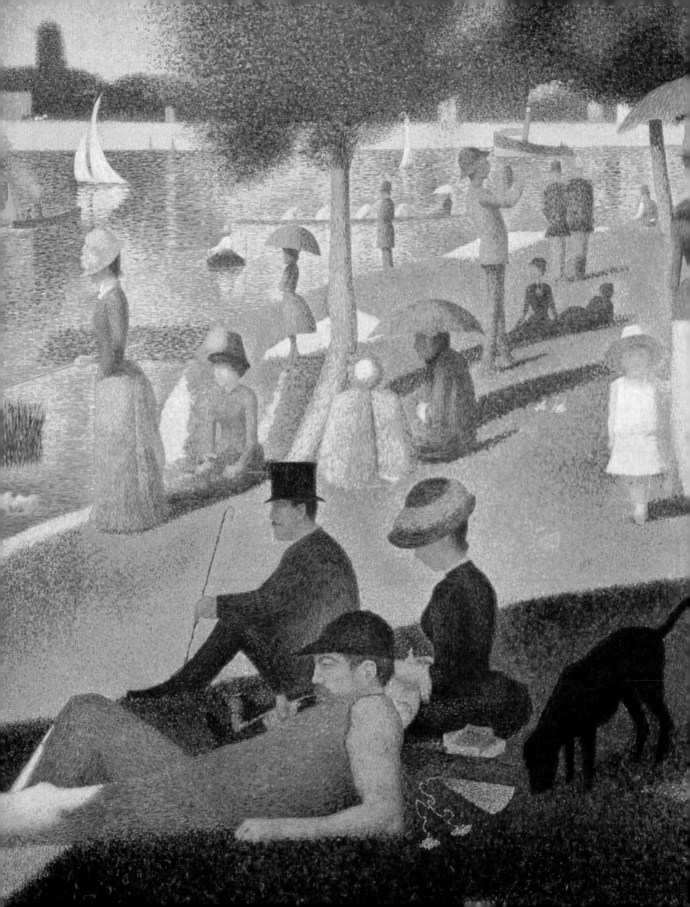

1863:
THE LUNCH ON THE GRASS
(EDOUARD MANET)

1866:
WOMEN IN THE GARDEN
(CLAUDE MONET)

1867:
GARDEN OF SAINT-ADRESSE
(CLAUDE MONET)

1868/69:
THE BALCONY
(EDOUARD MANET)

1869:
LA GRENOUILLERE
(CLAUDE MONET)

WOMAN IRONING
(EDGAR DEGAS)

1871:
RACEHORSES AT LONGCHAMPS
(EDGAR DEGAS)

THE DANCING CLASS
(EDGAR DEGAS)

1872:
THE BRIDGE AT VILLENEUVE-LA-GARENNE
(ALFRED SISLEY)

1873:
IMPRESSION, SUNRISE
(CLAUDE MONET)

POPPIES
(CLAUDE MONET)

1874:
BOATING (EDOUARD MANET)

THE MONET FAMILY IN THEIR GARDEN
AT ARGENTEUIL
(EDOUARD MANET)

A COWHERD AT VALHERMEIL,
AUVERS-SUR-OISE
(CAMILLE PISSARRO)

LA LOGE (THEATRE BOX)
(AUGUSTE RENOIR)

1875:
WOMAN AT HER TOILETTE
(BERTHE MORISOT)

ABSINTH (OR: IN THE CAFE)
(EDGAR DEGAS)

1876:
NUDE IN THE SUN
(AUGUSTE RENOIR)

DANCE AT THE MOULIN DE LA GALETTE
(AUGUSTE RENOIR)

1877:
NANA
(EDOUARD MANET)

PARIS STREET, RAINY DAY
(GUSTAVE CAILLEBOTTE)

SAINT-LAZARE STATION
(CLAUDE MONET)

1878:
MADAME CHARPENTIER AND HER CHILDREN
(AUGUSTE RENOIR)

RUE SAINT-DENIS,
CELEBRATION OF 30TH JUNE 1878
(CLAUDE MONET)

IN THE CONSERVATORY
(EDOUARD MANET)

1879:
YOUNG WOMAN SEATED ON A SOFA
(BERTHE MORISOT)

1880:
THE CUP OF TEA
(MARY CASSATT)

LUNCHEON OF THE BOATING PARTY
(AUGUSTE RENOIR)

1860s 1870–1875 1876–1880

TIMELINE